DRAWING

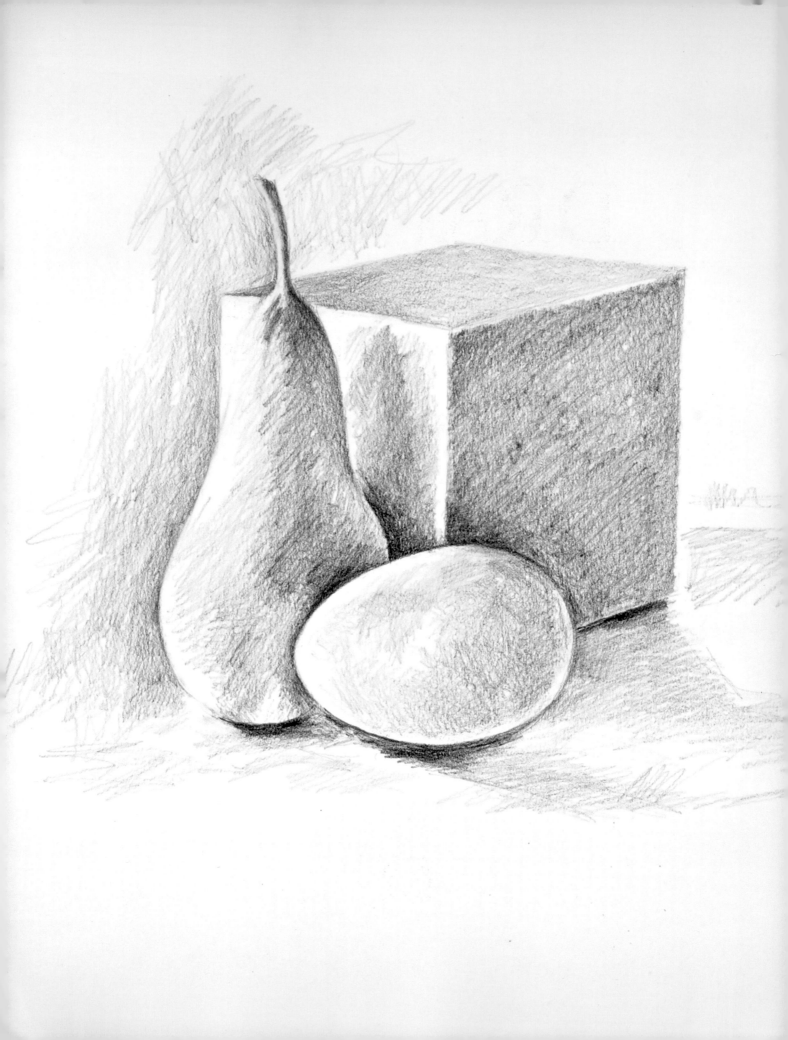

DRAWING

TECHNIQUES AND TUTORIALS
FOR THE COMPLETE BEGINNER

CHRISTINE ALLISON

First published 2017 by

Guild of Master Craftsman Publications Ltd

Castle Place, 166 High Street, Lewes,

East Sussex, BN7 1XU, UK

ISBN 978 1 78494 388 2

A catalogue record for this book is available from the British Library.

PUBLISHER **Jonathan Bailey**
PRODUCTION MANAGER **Jim Bulley**
SENIOR PROJECT EDITOR **Dominique Page**
EDITOR **Nicky Gyopari**
MANAGING ART EDITOR **Gilda Pacitti**
DESIGNER **Terry Jeavons**
PHOTOGRAPHY **Terry Jeavons except for: Shutterstock/Burhan Bunardi** front cover
(*bottom right*), **Christine Allison** pages 71 (*centre*), page 85 and 88; **iStock Photography**
page 86 (*luxizeng*) and 87 (*luisrsphoto*).

Set in Baskerville Roman
Colour origination by GMC Reprographics
Printed and bound in Malaysia

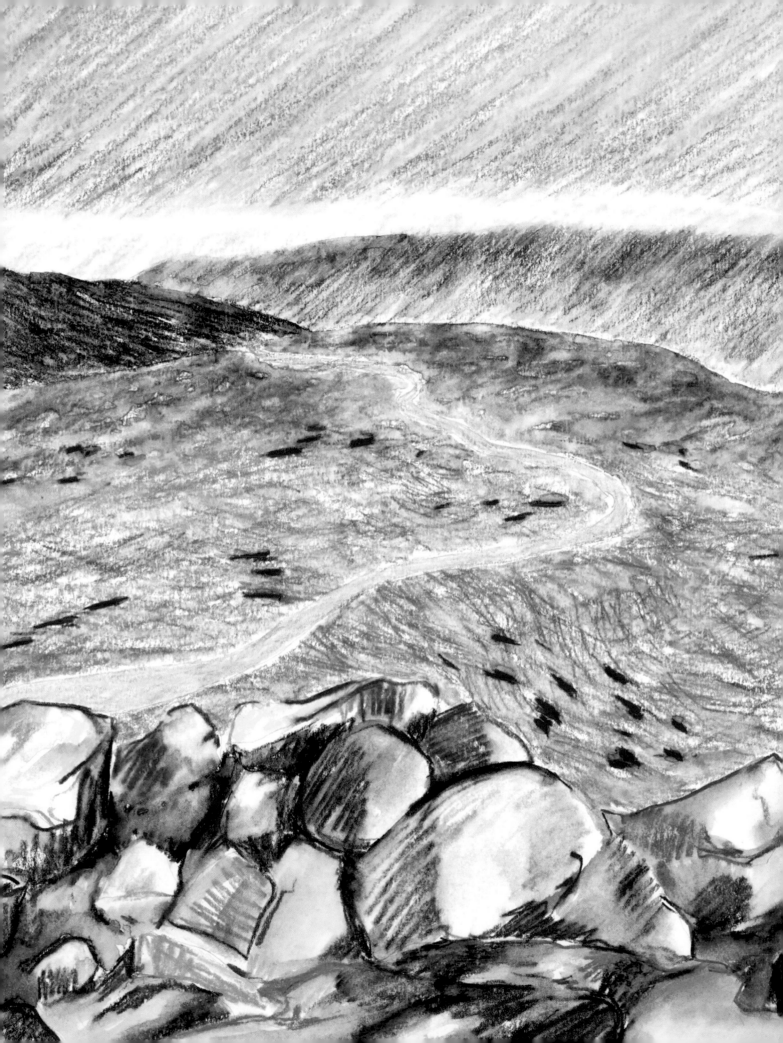

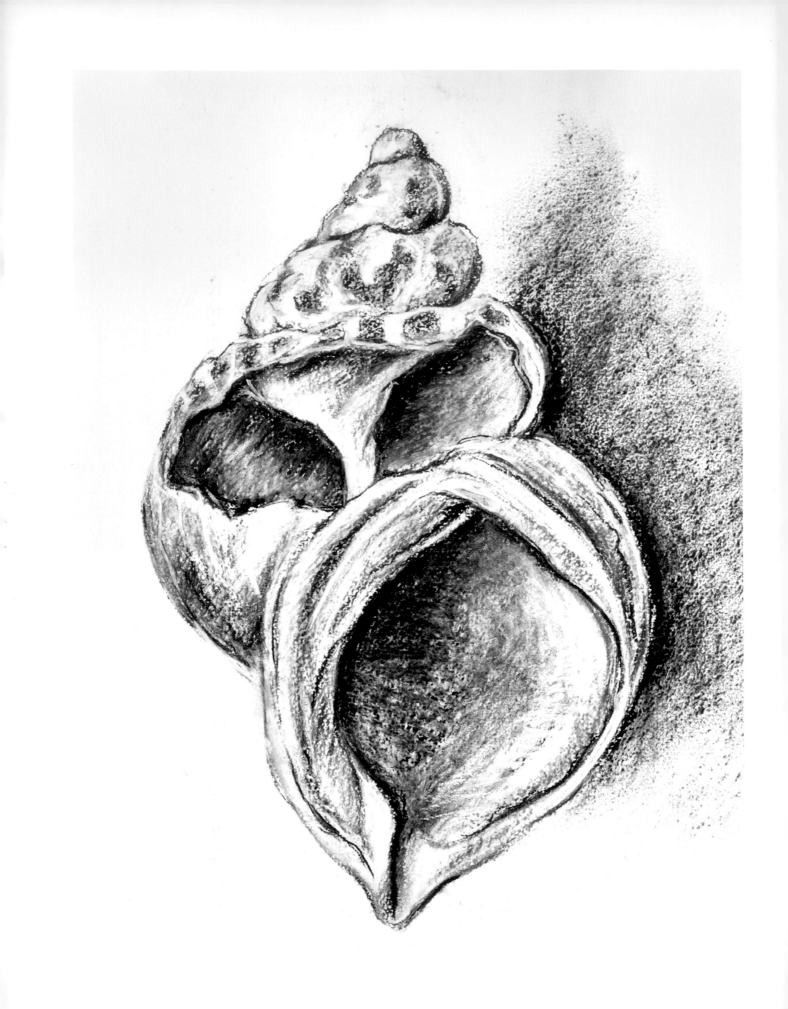

Contents

Introduction

Hello, I'm Christine, I'm an artist and I can draw. On these pages I will lead you to the realisation that you too can draw.

So many people say they can't draw, when really that isn't the case. Here's an analogy: imagine you are in an empty room, with only a piano in the middle. For some odd reason you have to wait in this room for a while. What will you do? You will probably go to the piano and… 'plinkity-plonk' or 'da-da-da-da' or 'dink, donk, bang' – you will play the piano. Therefore you can play the piano.

'But I can't PLAY the piano,' I hear you say. I disagree. You can play the piano – you can press the keys and make different sounds. Some of the sounds might be quite pleasing, some might make you wince, but you can play the piano. No doubt you think you can't because you can't hit the keys in the right order to make the sounds of a popular tune or a Chopin concerto. But you can play the piano; you just need someone to show you how to press the keys in a particular sequence to sound like Chopin or Sir Elton John, and then you would need to practise. You might even, in time, add some twiddly bits of your own that Chopin hadn't thought of! It's the same with drawing.

This is where I come in. Like you, I can draw; however, while you have been doing other important things with your life I have been experimenting, making marks and practising drawing for a long time. I have made drawing one of the most important aspects of my life. I love looking at drawings made by other people, especially the masters, but I also love looking at my own drawings, the ones I have made over the years in sketchbooks. When I look through any of my sketchbooks I can remember making each drawing. I am transported back to how I felt, where I was, who I was with, and so much more. They are rather like all the photos I have on my mobile phone but much, much better.

Each drawing, whether a scrappy scribble or a two-hour study, required a lot of me. I really had to look at what I was drawing. I had to sort through shapes, tones, lines and patterns, to pick out what I needed so that I could convey something about what I was looking at via my hand and onto the page. Each drawing required me to be fully engaged and present in the moment. I bring myself, my likes and dislikes, my personality, my experiences, my studies, my practice, my mood, my choices to every drawing I make. My drawings are mine – good, bad or indifferent. I own my drawings.

In this book, I would like to give you the information and inspiration to empower you to make your mark through drawing. We can work on this together. There are ten projects designed to build your skills of observation and mark-making and give you experience of using different drawing materials. I suggest you work through the projects in sequence. Before you start the projects read the information and follow the experiments in the sections on making marks, line, tone, colour and composition. These refer to the formal elements of drawing, which form the foundation for every drawing you will ever make. Keep a sketchbook of all your experiments; it will become an invaluable record of your journey. I will make suggestions, show you techniques and nudge you along. Your job is to play, experiment and practise so that you can have the pleasure and satisfaction of saying, 'I can draw and these are my drawings. They are mine, I own them and I'm proud of them.'

Let's get drawing!

Christine Allison

Materials and Equipment

There are various art materials and tools that will be helpful for you to work through the projects in this book. However, be flexible and use something similar if you don't have the specific items listed here – and be warned, art shops can be very seductive places!

Paper

I recommend buying an A3 pad of smooth, heavyweight cartridge paper. You can use most drawing materials on this surface except charcoal. For charcoal, it's worth investing in a couple of sheets of rough cartridge paper: charcoal becomes dust when you draw with it and needs a rough surface with a 'bite' to hold that precious dust that is your drawing. If you like the idea of using a coloured or tinted paper as an alternative (perhaps for the Sea Shell project on page 56) then look at the sugar or Ingres paper ranges.

You will need a sheet of tracing paper to replicate a drawing (used in the Tree Studies on page 36), although I often use a piece of kitchen greaseproof paper, as it does the job just as well.

Lastly, invest in a hardback stitched and bound cartridge paper sketchbook. These come in various sizes and shapes – A4 or A5 sizes are both easy to handle and comfortable to work with. (For more information on paper sizes, see page 90.) Avoid spiral-bound books as pages tend to fall out and it is too easy to remove pages. I always say that if you don't like something you've drawn, do something about it. Don't tear it out!

Basic items

You will need a ruler, a craft knife for cutting paper, a pencil sharpener, erasers of various types and a can of spray fixative to preserve your work. It is essential that you use fixative on charcoal drawings in particular as charcoal is very unstable and is easily brushed off the surface of the paper spoiling your work. Fixative can also be useful on graphite pencil drawings especially if the softer B range of pencils has been used as these too can easily be accidentally smudged.

A firm surface to rest your drawings on is essential. A wooden drawing board is preferable, but a piece of thick cardboard called 'greyboard', which is cheap and can be bought in most art shops, works very well to begin with. An easel is a useful item to own but is something you can acquire flater as it isn't essential for the beginner. If you prefer to sit when you are drawing a table easel might be more preferable than a standing easel.

Pencils

A good range of graphite pencils is a basic requirement. You don't need the entire hard and soft range, though. Start by buying an H, HB, B, 3B and 6B. The H is hard and makes fine marks; HB makes a slightly darker mark but is still quite hard. Then the B range becomes increasingly softer and darker as you progress up the scale to a 6B, or even higher to a 7 or 8B. However, even if you only own one B pencil you can still make a wide range of tones and it can be sharpened to a fine point to make a delicate line. (See page 90 for US pencil grades.)

Charcoal

Charcoal drawings require both thick and thin charcoal. The finer pieces are suitable for lines that are sensitive, specific and particular. Thick charcoal is used for thick lines and also for rich, dark shading and mark making. White compressed charcoal or white chalk is great for adding highlights to your charcoal drawings and making a softer grey when used with the black charcoal. Paper stumps look rather like pencils but are made entirely of compressed paper. They come in various sizes. Use them for smoothing the charcoal dust into the 'bite' of the paper and creating more even tones. They work well with soft graphite pencils, too.

Pens

Pens are lovely to draw with. I suggest starting with three types: a ballpoint, a water-soluble, ultra fine rollerball and a double-ended, water-soluble marker. All three make a good range of marks and are smooth and fluid to draw with, especially for quick sketching. Felt pens come in all sorts of colours and are very useful when sketching outdoors as they are convenient and not at all messy. With the water-soluble type, you can also add water with a brush to create tones. Alternatively, with non water-soluble pens you can cover the pen drawing with a wash of watercolour, and the ink of your original drawing will not bleed.

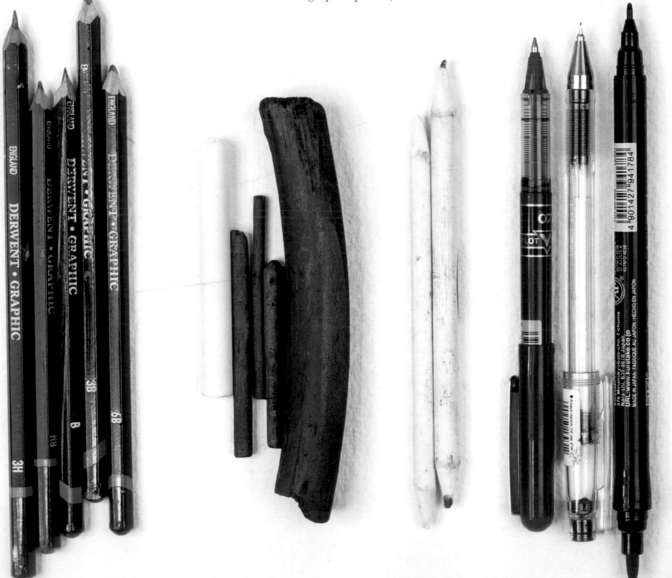

Paintbrush

You will need a small- to medium-sized soft paintbrush to add water to all of the water-soluble media.

Coloured pencils

Drawing with colour can be such a joy. Start off with a set of good-quality, water-soluble, coloured pencils. Buy the biggest box you can afford with at least 24 or, even better, 36 colours. If you can, invest in a wide range of colours so you won't get frustrated trying to mix the impossible. Although you can blend colours together to create more colours, some, such as turquoise, can be difficult to mix.

Wax pastels

Really, coloured pencils are all you need to make coloured drawings but I also love water-soluble wax pastels for their smoothness and colour range. I recommend buying a set of these in addition to pencils. Again, buy a set of at least 30 for a good range of colours. I particularly like the way they become 'painterly' when water is added and how easily the colours mix together. They also make bigger marks than pencils, so you can use them to make gutsy drawings.

Ink blocks

I have also used water-soluble ink blocks in one of the projects (the Sunrise on page 72). These are not a necessity, but if you are feeling very self-indulgent they are a pleasure to work with. The colours are intense, and their block form means you can use them on their side to cover large areas of your paper with colour, which is great for big skies or sweeping landscapes on larger pieces of paper. You can also make sharp lines and marks with them by drawing with the corner of the block.

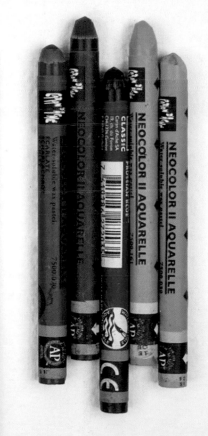

Making Marks

The art shop can be a real temptation to an artist, full of all manner of exciting products. But really all that's needed when you have that creative urge is yourself, paper and a pencil.

That said, experimenting with different mark-making media or 'kit' *is* exciting and something to continue doing as you progress on your journey as an artist.

In this book I have designed projects that use a basic range of media so that you won't need to buy every type of pencil, crayon or pen on the market. Before you begin the projects it is a good idea to experiment with each to see how they feel to draw with and find out what each can do. I suggest making a series of squares on a sheet of paper or tearing up squares of different papers, then draw something simple, such as a leaf, in each square. Use something different to draw with in each one. You could then collage your experiments in your sketchbook or on a separate sheet and make notes on what you used for future reference.

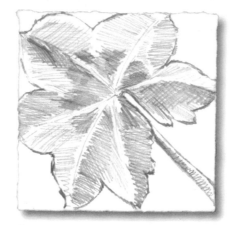

1 *Sharpened hard HB and H pencils are good for creating sharp details and fine marks.*

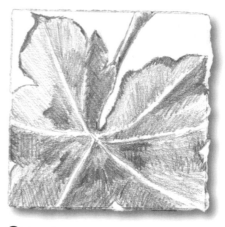

2 *Hatching using B and 2B pencils is still quite fine but softer than the HB.*

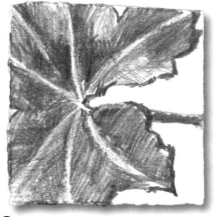

3 *Pressing harder and harder with a soft 6B pencil makes rich, dark marks for shading.*

BELOW *Being playful with materials is highly recommended. Each of these 'doodled' patterns could also be used in drawings to describe shape, pattern, texture or form.*

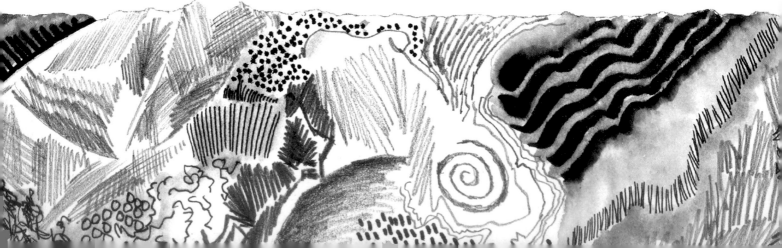

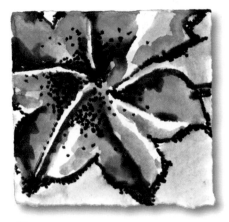

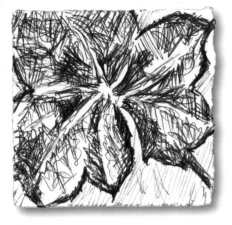

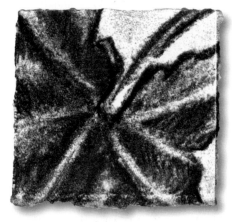

4 *Use the fine end of a water-soluble marker pen for pattern details and the thick end for bigger marks. Adding water with a brush creates tones and lines that bleed.*

5 *Cheap and easy to use, with ballpoint pens you can make all sorts of free-flowing marks.*

6 *Use thick, dark charcoal on grained paper and make drawing marks with an eraser.*

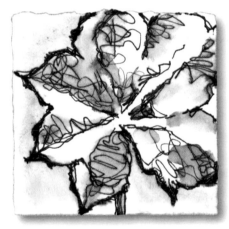

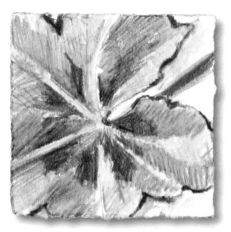

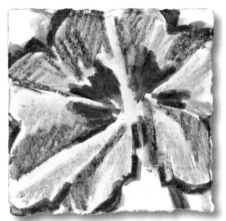

7 *Squiggly, free-line work can be created with a water-soluble, ultra fine rollerball, and a brush and water can add more tones.*

8 *Water-soluble pencil crayons can be used to blend colours with hatching and cross-hatching, then add water with a brush.*

9 *Water-soluble wax pastels are ideal for chunky marks and vibrant colours, especially when water is added.*

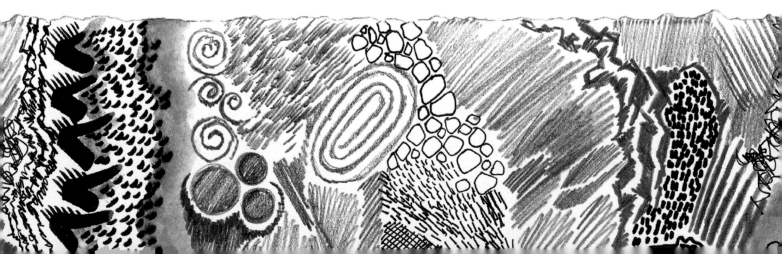

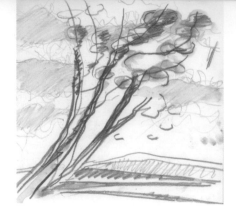

Line

Drawing is all about using lines. Lines can be packed together to create shading, or long and continuous to describe an outline. They can be fluid, broken, jagged, smooth, fuzzy, fat or thin.

Lines can also be expressive, as in sensitive, energetic, quiet, fast, timid or angry. When you draw, the sort of line you make often unconsciously reflects your mood. Equally, you can use different lines consciously to express the mood you want to project in your drawing. The subject you are drawing can lead you to make a particular type of line, too. For instance, you would intuitively use a gentle, sensitive line to draw a sleeping baby and quite the opposite type of line to catch the ferocity of a howling gale at sea before the rain got to you.

What you use to make your lines will also help you to express something about your drawing. For example, it could be quite difficult to make a 'quiet' drawing with a big, chunky stick of black charcoal. You would be better off with an HB pencil, a fine pen or even a thin, fragile piece of willow charcoal. However, if you try to make a 'loud' line with the fine piece, it will break. Instead, press hard with the chunky charcoal, which is better for big, strong lines.

Sometimes we use a single line to describe our subject when we are drawing and at other times build the line using small marks. These small

marks are exploring marks, which we use to find the line we want. Gradually the line we are looking for emerges as we add each mark. We do this particularly when we are carefully trying to draw something accurately from observation.

Just as you would choose the most appropriate tool for any job, choosing the best sort of line will help you to make a good job of your drawing. Take time to experiment in your sketchbook making different weights of line using pencils, pens, chalks, charcoals, crayons and pastels, as shown below. Also try to express different moods and emotions in line, such as sensitivity or anger. Look at the types of lines used by other artists in books and art galleries, have a go at copying them and in so doing build up your own reference library of line.

LEFT *Experiments in making expressive lines.*
BELOW *Different weights of lines using different media.*

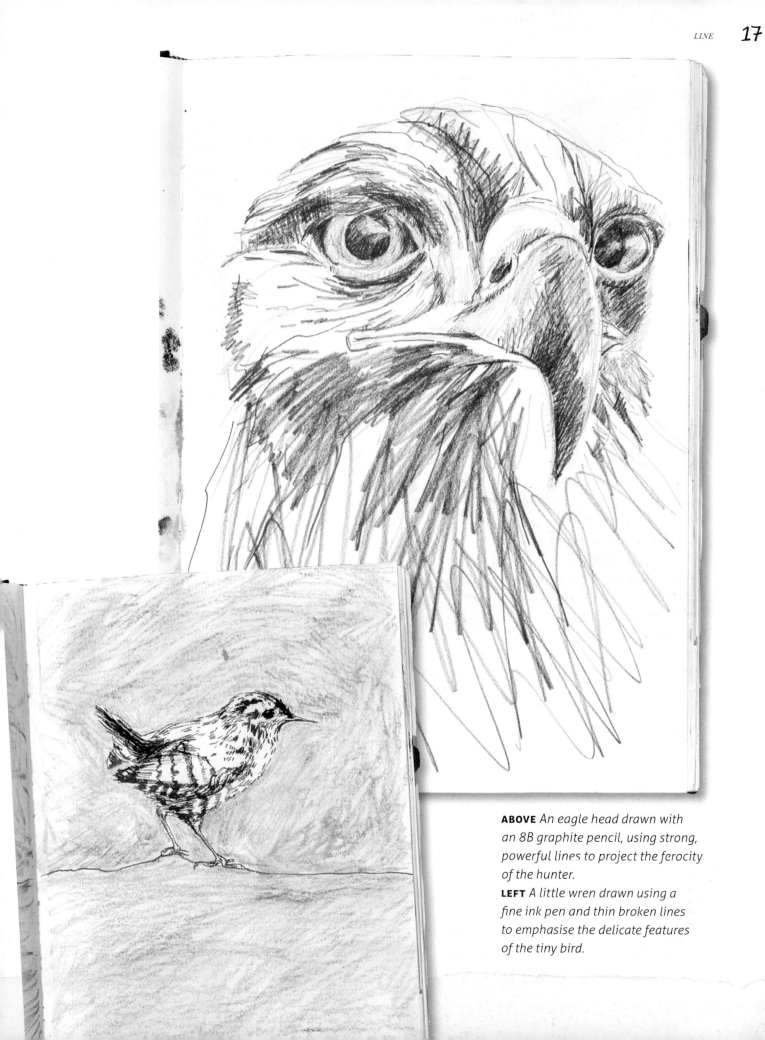

ABOVE *An eagle head drawn with an 8B graphite pencil, using strong, powerful lines to project the ferocity of the hunter.*

LEFT *A little wren drawn using a fine ink pen and thin broken lines to emphasise the delicate features of the tiny bird.*

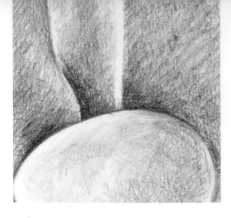

Tone

More often than not, when we make a drawing we will combine line and tone. Line helps us to find the shape of what we are drawing and tone gives us the means to describe its form.

As light hits an object, graduations of lightness and darkness are created over its surface. These graduations illuminate the angles and corners, bumps and hollows, curves and flat areas. If we want to make our drawing look three-dimensional then we need to use different shaded tones to describe what the light is showing us. To do this we use the tonal scale, which goes from white or very light, through greys, to very dark or black.

An interesting exercise to help you in your use of tone is to paint a few objects white then place them together as a white still life. Observe closely how the light moves over the surfaces of the objects, creating lighter areas and darker areas in shades of grey. Try drawing what you see using a 2B graphite pencil.

If we are making a tonal drawing of coloured objects, then we also use tone to try to describe their colour. We call the actual physical colour of a thing 'local' colour. For example, the local colour of a tomato is red, that of a banana is yellow. Tonally, yellow is lighter than red, so it is quite easy to

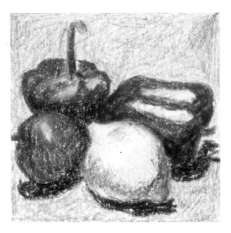

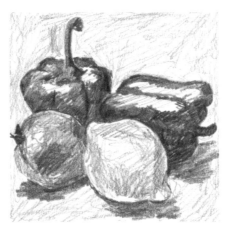

ABOVE TOP *Still life using local colour.*
ABOVE *The same still life using the grey tonal scale shown below.*

put down a lighter grey for yellow and a darker grey for red. It is, however, more difficult to differentiate between, say, red, green, brown or blue. Tonally they could appear very similar on the grey tonal scale. So in reality we can only use the greys to say whether the local colour of an object is lighter or darker than another, and then in addition describe how it is modelled with shades of light and dark.

Another useful exercise is to make an arrangement of different-coloured objects and draw them using tone rather than line. Try to include a dark object in your still life, perhaps something with a local colour of dark green or blue, and something of a lighter local colour such as yellow. Then use a lamp to shine a strong light on the dark object. Observe what happens tonally to that object – the illuminated area can appear to be even lighter than the yellow object. This is called 'perceived' colour. You might 'know' it is dark green, but if you want the drawing to be a true representation then you must draw what you perceive, not what you think.

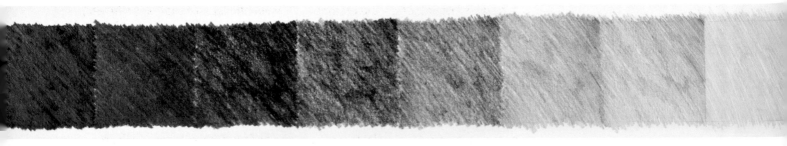

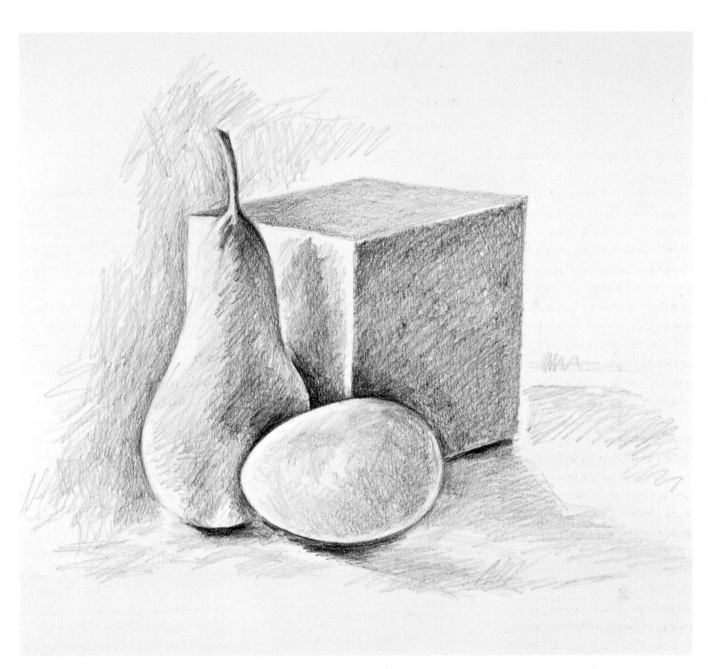

For this tonal drawing I painted a square box, a pear and an egg with white acrylic paint and set them up with strong light coming from the left side. Notice that we only see some of the edges because of the darker tone behind the edge, as in the pointed end of the egg and the left side of the pear. At times, if the tone is the same, we don't see the edges at all. Look at the top left of the pear and the box behind it: the edge of the pear disappears. On the right side the edge of the box is noticeable because of the lighter tone behind it. Each side of the box is a different tone because of the light. Notice that the darkest tones are under the objects where the light cannot reach. Indeed, we use tone to depict the effect of the light on a surface.

Note: be careful with your painted egg, I turned my back on my still life for a moment and mine disappeared, only to be found in a mess on the floor!

Colour

Traditionally, colour was more known for its use in painting rather than drawing, but now there are so many exciting drawing materials available that drawing with colour is quite usual.

Both drawing and painting use media that is pigment-based. Each different colour can be lighter or darker in tonal value, just like the graphite on a grey tonal scale. With colour you can add white to make a lighter tone or add black to create a darker tone. The degree to which you do this alters the colour from light to dark.

The use of colour is also about relationships. Placing one colour next to a different one or mixing one colour with another will mean the colours have an effect on each other. A basic chart of colour relationships is usually depicted as a segmented wheel. There are three primary pigment colours: red, blue and yellow. These are the three basic colours that you cannot mix yourself. However, mix these primary colours with each other and you can make three new secondary colours: purple (red+blue), green (blue+yellow) and orange (yellow+red). Clearly, it doesn't stop there; further mixing of combinations will create many, many more colours. Mix the three primaries together in equal quantities and you get black.

If we pair up colours opposite each other on the colour wheel we get combinations called complementary colours. The basic three pairs of complementary colours are blue and orange, purple and yellow, and red and green. These colours have the effect of intensifying each other when placed next to another and they can vibrate and dazzle. Colours that are close to each other on the colour wheel, such as yellow, orange and red, or green, blue and purple, are usually described as harmonious.

As human beings we have symbolic, emotional and cultural relationships with colour, and the advertising industry in particular employs specialists to ensure their products are packaged in colours to which we will subliminally respond and therefore, potentially, pick up and buy. Colour theory is a fascinating subject, but there is no better way to find out about its use and effect than through experimentation. Different media will react in different ways depending on the purity of the pigments they are made from, and I suggest you 'play' with colours. You could make yourself a grid of squares, open up your box of pencil crayons and find out what they can do. Overlay them, mix them, place different colours next to each other, make light tones and dark tones, and then make drawings using your discoveries.

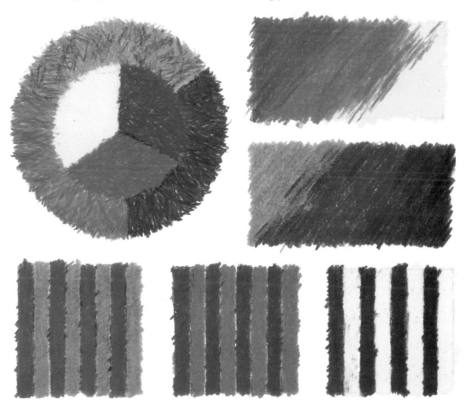

ABOVE TOP *Colour wheel showing primary and secondary colours and harmonious colour alongside it.*

ABOVE *Three pairs of complementary colours: red/green, blue/orange and purple/yellow.*

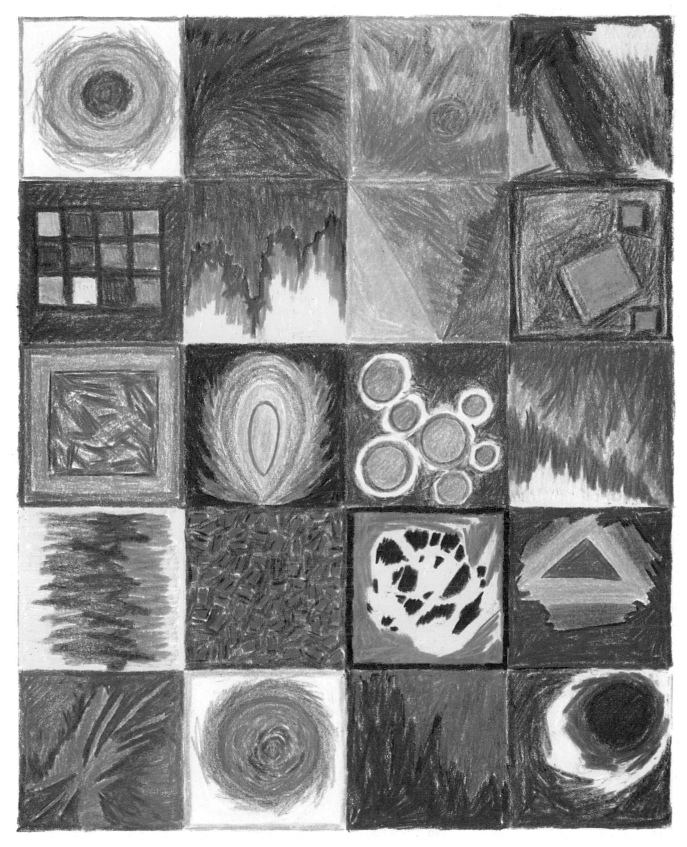

ABOVE *Use these examples to give you ideas for experimenting with colour.*

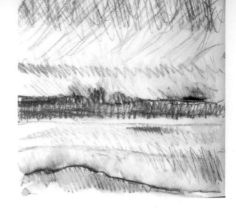

Composition

How you arrange the elements in your picture is called composition. It is one of the most powerful tools for an artist and yet many don't think about it. Be in control of your picture.

I will frequently say to students 'be in command of your rectangle'. By this I mean making conscious decisions about edges and the arrangement of elements within the shape and space contained by those edges. Just because paper comes in international sizes, this doesn't mean your drawings have to. The shape and size of the paper you work on speaks even before you make a mark on it. It says something about what you are doing. Choose a shape that suits the content of your work.

If you are going to use a rectangle, what sort of rectangle do you need? A rectangle that has its long sides horizontal is known as 'landscape' and a rectangle that has its long sides vertical is known as 'portrait'. So the first decision is which way up to use your paper – landscape or portrait? Rectangles can be extra long or extra tall. Rectangles can be calm or dynamic. Horizontal rectangles remind us of long, calm horizons either at sea or on land. Vertical rectangles are more upright and powerful, like totem poles.

You may prefer a square. Square shapes are very balanced and stable. We feel safe with a square. More difficult is a circle; it reminds us of a wheel and may move, but used carefully can be very interesting. More curious still are irregular shapes. They can be unsettling but will always grab your attention.

Once you have decided on the shape of your piece of paper, you need to consider how you will compose the elements of your picture within it. The content should always relate to the outside edges of the paper. If, for instance, you are drawing a landscape or a seascape, where across your rectangle are you going to put the horizon?

Look at the two seascape drawings opposite. The horizon is in a very different place on each drawing – one is nearer the top of the paper and the other is nearer the bottom. I made the choice and in so doing I was 'saying' this picture is about the sky and that picture is about the sea. If I had put the horizon across the middle I would be saying, this picture is equally about both.

When placing the main object or a person within a picture, where you put it is important. You can make it look dramatic or weak. What else needs to go into your picture? Everything, including space, is important and everything is seen in relation to everything else. Empty space can be a powerful force in a picture. Nothing is there by chance: you have put it there and you have chosen where to put it and how big or small it should be. This is your composition and you are the boss; therefore you must take command of your rectangle or square, or circle or whatever shape you have chosen and everything in it.

OPPOSITE *A high horizon and a low horizon are used to powerful effect.* **BELOW** *An extended horizontal rectangle suits this simple landscape.*

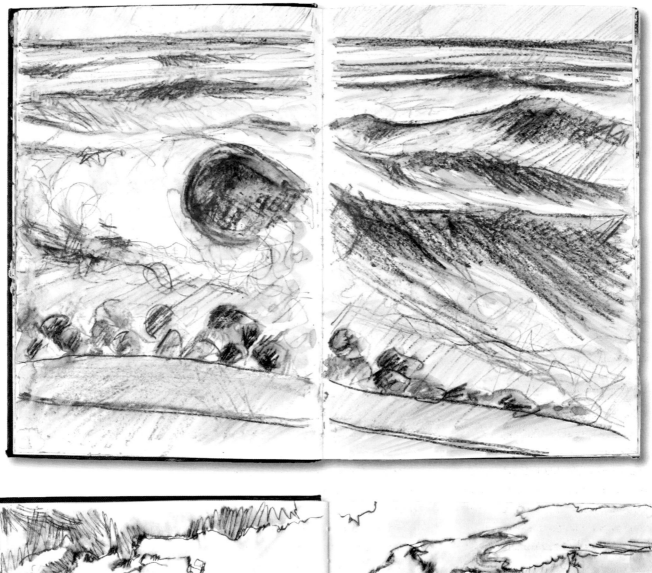

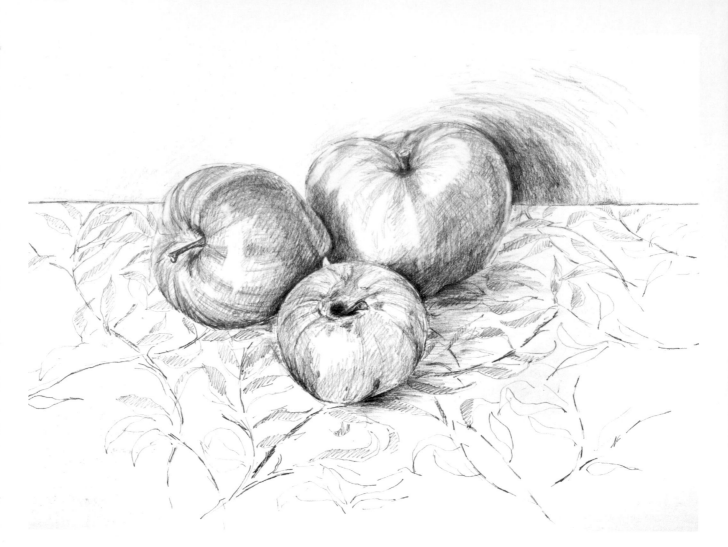

Three Apples

In this project you are going to make a life-size drawing of plump, shiny apples arranged on a patterned cloth, using 2B and 6B graphite pencils. You will use line and tone to describe the shape and volume of the apples. Lighting the apples from one side will help you to see the light, medium and dark areas of your still life, which can be interpreted as light, medium and dark tones. The patterned cloth gives you the opportunity to add interest and detail to your drawing.

YOU WILL NEED

3 apples of varying size and shape • patterned cloth • lamp

A3 sheet of smooth cartridge paper • 2B and 6B graphite pencils

eraser • pencil sharpener or craft knife • can of fixative spray

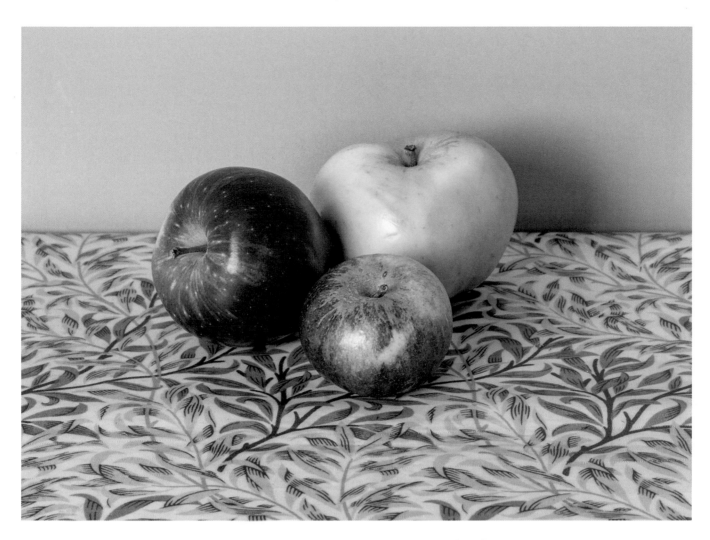

THE SET-UP

Choose a flat surface and cover it with your patterned cloth. Take the three apples and make an arrangement of them similar to that in the photograph. Notice how the apples overlap and relate to the horizontal position of the back edge of the table. A light-coloured plain backdrop or wall behind the apples is preferable to a busy one. This is your set-up. Make sure the arrangement is receiving either strong natural light or artificial lamplight from one side so as to create lighter and darker areas of shadow and shade.

Before you begin, spend some time looking at your set-up. Get to know it. Look at the curves and how they

Tip
On a practice page of your sketchbook, use your 2B sharpened pencil to lightly build curved lines like the shapes you observe in the apples.

intersect and relate to each other. Check where the horizontal line of the cloth behind the apples meets them at each side. Can you see any shadows under and between the apples? Are there any soft or harsh shadows on the back wall?

Look at the pattern on the cloth and practise drawing a section of it, just in outline. Try making different tones with both the 2B and 6B pencils. Press lightly to make lighter tones and press harder to make darker tones. Use diagonal and curved hatching marks to make the shading. Look at the tones you have made on the page and see if you can match them to light and dark areas on your set-up.

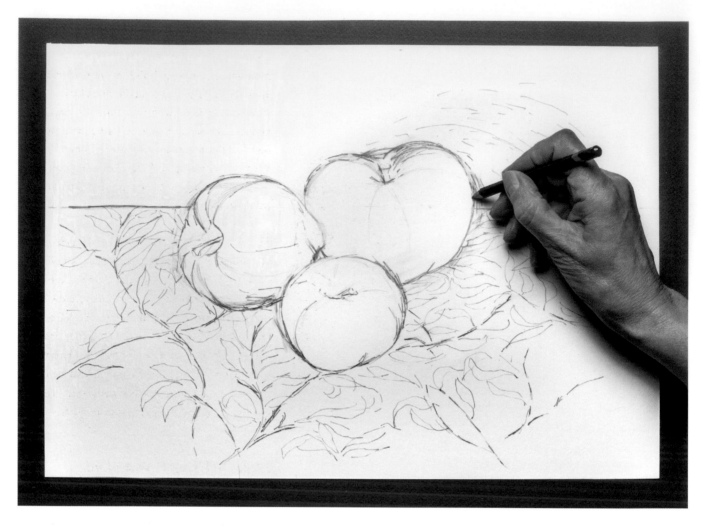

Tip

Don't expect to get it right first time. Work lightly as you search the space with your eyes and hand to 'find' the apples on your page. Resist rubbing out too much but keep looking and 'restating' your marks. Restating rather than erasing adds depth and depicts the history of your search.

STAGE 1 : *Composing and mapping out your drawing*

First look at your set-up and then look at the complete rectangle of your A3 piece of paper. You are going to draw your apples as near to life size as you can, measuring and estimating with your eyes. Imagine the apples and the cloth on your paper. Where will the horizontal line of the cloth sit on your page? Where will the top of your apple be in relation to the top edge of your page? Making these decisions is the art of composition – you are composing your drawing to sit comfortably within the rectangle of your paper.

Take your 2B pencil and begin to map in the shapes of your apples. Mark in the back edge of the cloth, taking the line of it right to the edges of your paper. Use gentle, light lines. Keep looking and checking how the curves of the apples meet and intersect. Build your lines with small stroking marks.

Indicate lightly the pattern of the cloth. Gradually map in the whole composition with a light line, adjusting and restating your lines until you are satisfied your line drawing accurately represents your set-up.

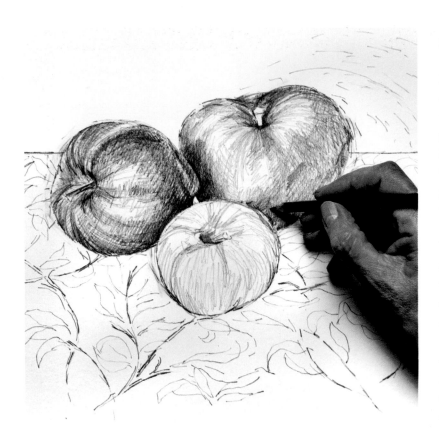

STAGE 2 : *Using tone on the apples*

Now you are going to build the tones of your apples, using shading to make them look three-dimensional with both your 2B and 6B pencils. In essence, you are representing the light, medium and dark areas on your apples and where they overlap with light, medium and dark pencil shaded tones. Shade gradually, building up from light to dark.

You will need to continue to make judgements and adjustments, looking, comparing and feeling your way around your drawing. Don't expect to arrive at the final tones immediately; allow your drawing to grow in depth of tone. Work from one area to another but keep looking at your drawing overall. Change the direction of your shading and use curved marks to help you describe the roundness of your apples. Stop when you feel you could pick up the apples from your paper!

STAGE 3 : *Using tone around and under the apples*

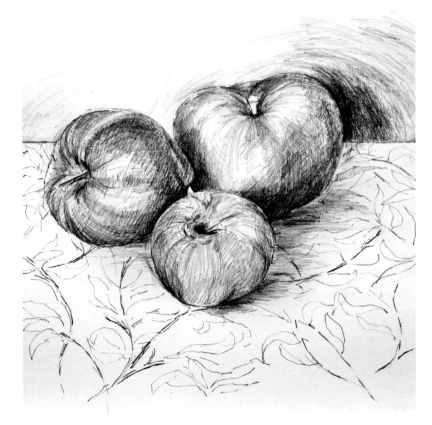

Look at the shadow on the wall behind the apples. How dark is it compared with the big apple in front of it? Use your 6B pencil to shade in the shadow, gradually blending from darkest to medium to lighter tones. Look under the apples. There is a subtle medium tone of shadow on the cloth. Notice how I have used horizontal shading to describe the shadow. This helps to give the feeling that the apples are sitting firmly on the cloth. Add this to your drawing.

Tip
Keep looking! How dark is dark? How light is light? What comes in between? How gradual are the transitions? Keep going back to what you did before, compare and restate.

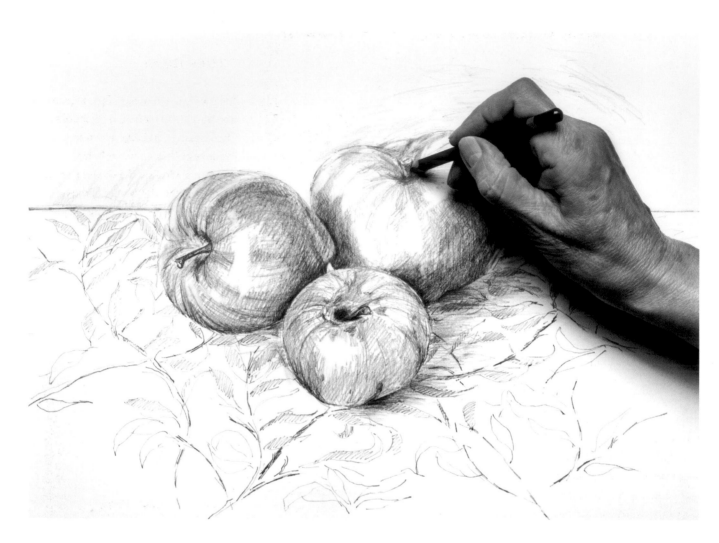

STAGE 4 : *Sharpening it up and adding detail*

Look at your set-up, then look at your drawing. Are there edges that appear sharp in your arrangement but which are fuzzy in your drawing? Take your sharpened 2B pencil and make precise lines where they appear sharp. Look at the markings on the apples and their stalks; draw them more precisely. Check that the lightest areas, the highlights, are exactly that… light! Look at the pattern of the cloth. Spend some time drawing the pattern more precisely but allow it to fade away towards the edges of the paper. Remind yourself that you are making a drawing, not a photographic reproduction. Allow your drawing to be arty round the edges. Do you like it? Are you pleased with it? What would you change next time? Your eye is your greatest critic and practice is your greatest teacher.

It is a good idea to spray your finished drawing with colourless fixative to help prevent it rubbing off and smudging.

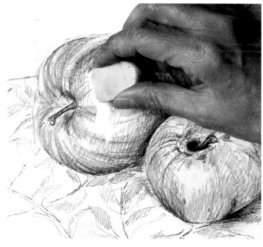

Add light by using your eraser to take out any greyness, which will make the high spots of your drawing white again.

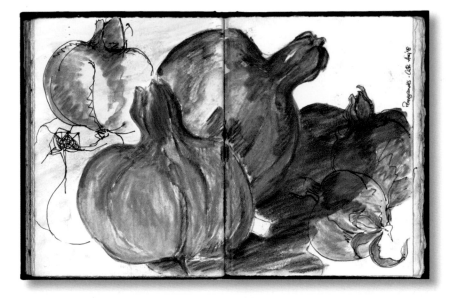

OTHER IDEAS

I made these drawings of pomegranates and pears in one of my sketchbooks after picking the fruit on a balmy evening walk in Crete with my daughters. I look at the drawings now and remember the beauty of the sky, the warmth of the air and the laughter of young company. Drawings are more than marks: they hold memories and emotions caught in the moment.

Look at my pages. How can they inspire you? You could choose and draw other fruits and have fun making arrangements of them on your pages. Try cutting some in half and drawing the details of pips and seeds. Use coloured pencil crayons or water-soluble wax crayons, adding water with a brush. You could use fine black pen to draw with and add the colour later. Creativity comes initially from inspiration but the result is yours and yours alone. Make your mark. Experiment and explore.

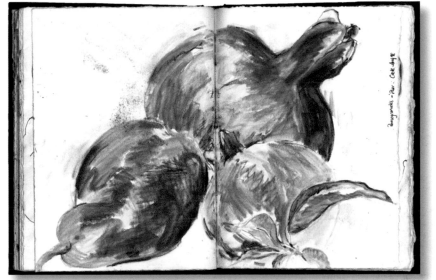

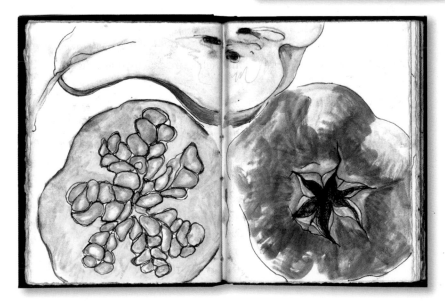

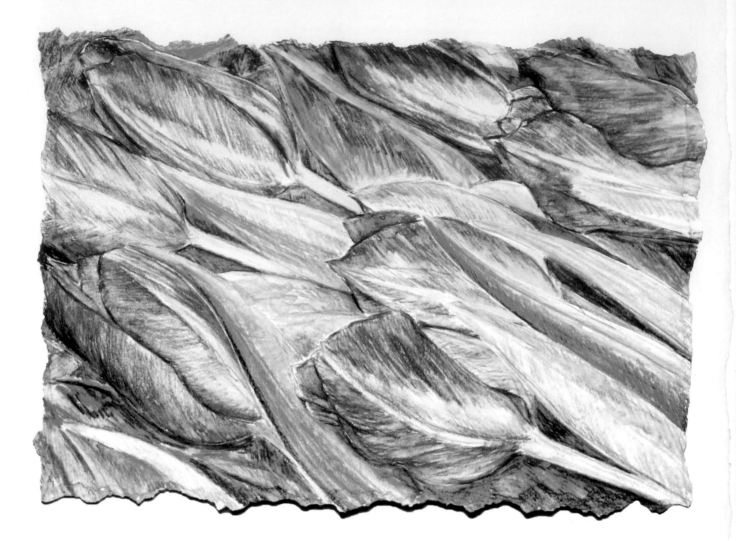

Tulips

This project practises the skills of line, tone and shading used in the apples drawing but now you will work in colour using water-soluble pencil crayons. Often when faced with drawing a whole bunch of flowers the complexity of the subject can be overwhelming. One technique to help with this problem is to simplify your view by isolating part of the bunch by using a 'window' to look through. The resulting composition also gives your drawing a contemporary feel. Tearing around your paper before you start to make a deckle edging adds a creative twist.

YOU WILL NEED

bunch of tulips • A4 sheet of paper • 2 x A3 sheets heavyweight cartridge paper
11¾ x 10in (30 x 25cm) piece of lightweight card • ruler • pencil • eraser • craft knife
masking tape • set of water-soluble pencils • small brush and water

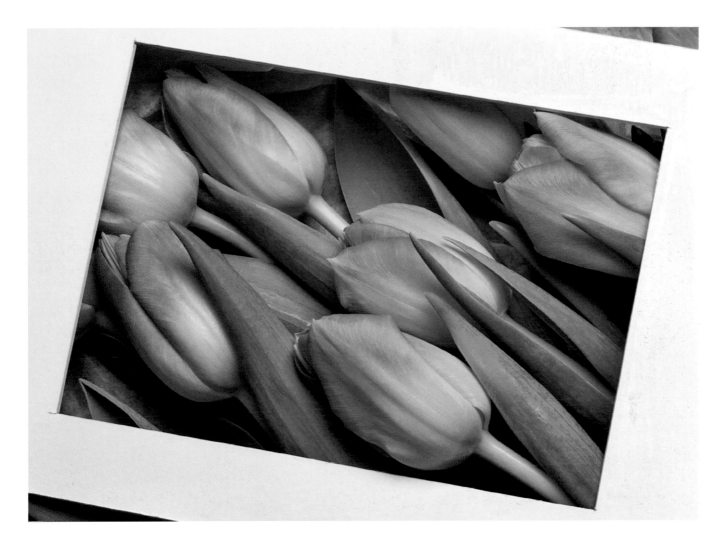

THE SET-UP

There is a little preparation to do before you start this project but it is worthwhile, as you will learn techniques to use in future drawings. First fold your A4 sheet of paper in half both ways. Open it out and place it on one of your A3 sheets of paper. Make a dot at each corner to mark the A4 sheet in the middle of the A3 sheet. Also mark where the half folds are on each side. Remove the A4 sheet. Join up the dots using your ruler and pencil. Make sure the halfway pencil marks fall within the drawn shape. You are now going to tear off the excess paper around the pencil lines to deckle the edges of the piece you will work on (*see right*).

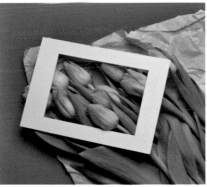

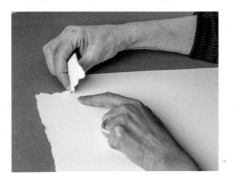

Now make the window to view your tulips through. Take the A4 sheet and fold it in half. Place the folded paper in the centre of the piece of lightweight card and mark the corners with dots. Remove the folded paper. Using the ruler and pencil, join up the dots. Cut out this rectangle using your craft knife and ruler. Make a pencil mark halfway along each side of your window.

Place the window over an interesting section of your bunch of flowers. What you see through the window is what you will draw.

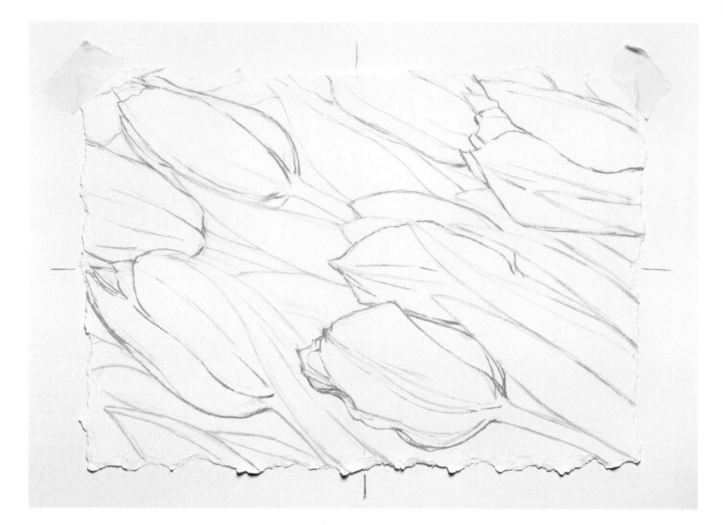

STAGE 1 : *Mapping out your drawing*

It is a good idea to place your deckle-edged drawing paper onto a piece of A3 paper to create a backing sheet and tape it down at the corners. Also make a pencil mark on your backing sheet halfway along each side. Select two coloured pencils: a light green to use for the leaves and a light colour found in your tulip petals. Use these two coloured pencils to draw the outlines of the leaves and tulip flowers you can see through your window. The halfway marks can help you work out the scale. Look where these marks are on your window frame and where similar marks are on the backing sheet of your drawing. Which parts of the flowers and leaves are they next to? Work from these across your drawing both ways. Take time to build your drawing as accurately as you can.

Use small strokes to make your lines, observing how the petals and leaves intersect, and correcting and restating just as you did when drawing the apples.

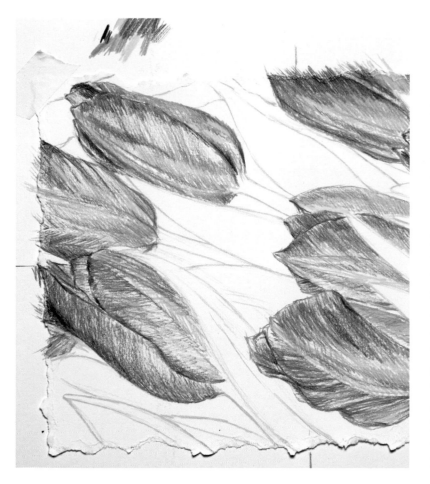

STAGE 2 : *The tulip flowers*

Look closely at your real tulips and select coloured pencils that are similar in colour to the petals. For the tulips in the photograph I need two yellows, two pinks and a deeper magenta for the edges of the petals. Experiment with blending the colours on the backing sheet. Work lightly, building up the colours as you did the tones on your apples. The colours can be overlaid to create more colours. Yellows and pinks will make shades of orange when worked over each other. Study the petals and shade with your crayons in the direction of the natural forms and curves. Look at which parts are lighter and which are darker. Be particular at the edges of petals – some will need the darker magenta to define them. Leave little bits of white paper showing to add air and light to your drawing. Take your colours right to the edges of the paper, over the deckle edge and onto the backing sheet. Do this throughout your drawing. (When you take it off the backing paper at the end it will have clearly defined coloured edges.)

STAGE 3 : *The stems and leaves*

Now look at the colours of the stems and leaves and select a range of green crayons that are similar colours. Notice how the leaves under the top flowers are much darker and in shadow. Choose a dark blue to blend with the greens in these areas. The darker parts of your drawing provide a good contrast to the lighter coloured flowers and add depth. Before you start, practise blending the colours on your backing sheet. Begin with the stems and notice how the light and shade make them look rounded. Leave a little white paper for the highlight if there is one. Gradually blend and build the colours and tones of the leaves. Notice the lines along the leaves. Lightly blend blue into the greens in the shaded areas of the leaves such as the inner curves. Then look to the darkest areas underneath. Use your darkest green and blue together in these places. Note how the dark helps to define the edges of the flowers, stems and leaves.

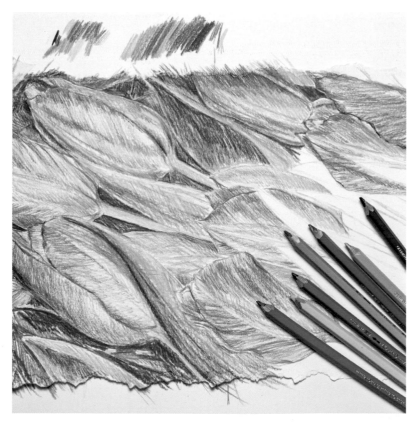

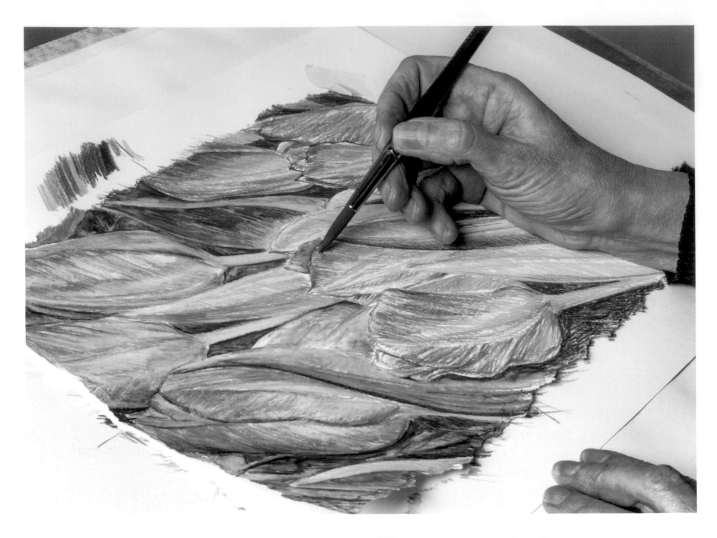

STAGE 4 : *Adding water to your drawing*

When water is brushed onto water-soluble pencils it activates the pigments and enriches the colours. It is important to wash your brush between colours just as you would if you were painting – carrying blue from the background to the flowers would result in green and purple petals! Ideally you want to blend the colours with the water but also retain some of your drawing marks. Too much water or too much pressure will lose the drawing quality and turn it into a painting. Work over your drawing with the brush and water carefully. Allow it to dry then take it off the backing sheet. Lay it on a clean piece of paper to appreciate the beauty of the edges and, of course, your drawing.

Experiment on your backing sheet with different amounts of water and brushstrokes on the coloured crayons.

OTHER IDEAS

Flowers and other plants have been a popular
source of inspiration for artists for centuries.
I am lucky to have a large garden overflowing
with flowers and vegetable plants, so I only have
to step outside my door to be inspired. These
drawings from one of my sketchbooks show a
globe artichoke and some cosmos flowers. The
artichokes are good to eat, but if left on the plant
they go on to produce wonderful, purple, spiky
flowers that attract all sorts of insects.

Even if you don't have a garden, bunches of cut
flowers from your local supermarket are quite
cheap and plentiful, and the florist shop will
allow you to buy single stems of particular flowers
such as lilies. You could make studies of all sorts
of blooms from the ordinary to the exotic.

Pot plants are another idea. Even on wet, wintry
days you can draw from a potted orchid. These
popular plants are easy to maintain and boast
the most wonderful sculptural flower shapes for
you to tackle.

One of the nicest ways to enjoy drawing flowers
and plants is to take yourself, your sketchbook
and pencils to a local park or botanical gardens.
Also take your camera. Make a sketch out there
in front of the live plant but photograph it too so
you can finish your drawing at home.

Should you be lucky enough to be given a bunch
or bouquet of flowers for a special occasion, what
better way to create a precious memory than to
record a drawing of even one flower from it in
your sketchbook? Your drawing will last long
after the flowers have wilted and died, and it will
be a lasting memory.

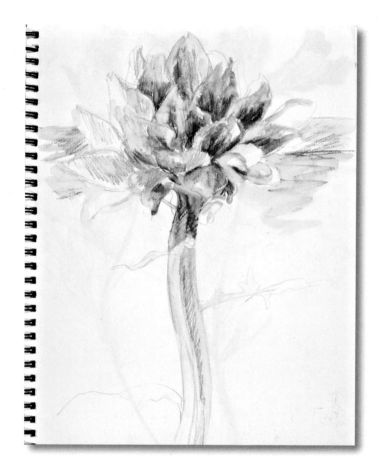

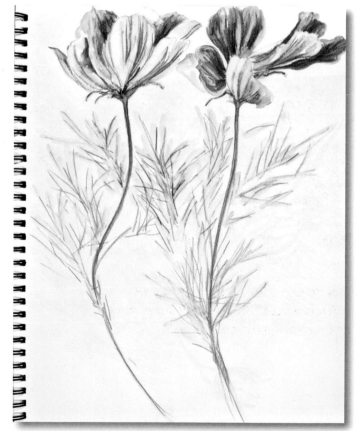

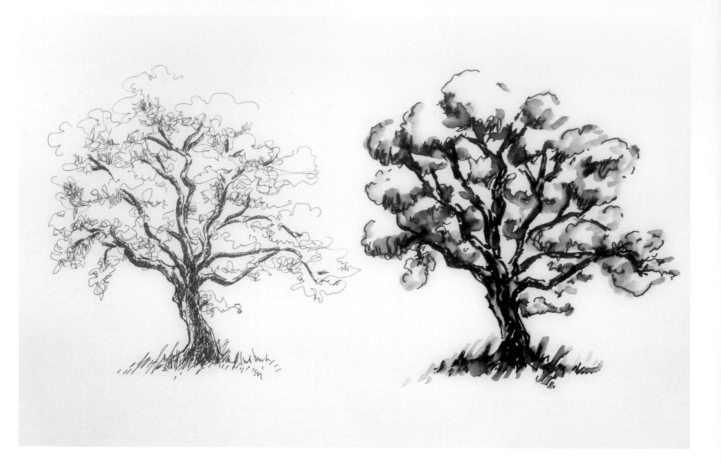

Tree Studies

Trees are excellent subjects for observational drawing practice, but trees in full leaf can be quite
a challenge because there are so many leaves! In this project you will make a study sheet of
two trees using one photograph for reference, either your own or the one pictured here.
Using two different pens, you will learn how to see and draw a tree with confidence.

YOU WILL NEED

a reference photograph of a tree • A3 sheet of cartridge paper

A3 piece of tracing paper • HB pencil • blue ballpoint pen

black thick and thin, double-ended, water-soluble felt pen

eraser • small brush and water

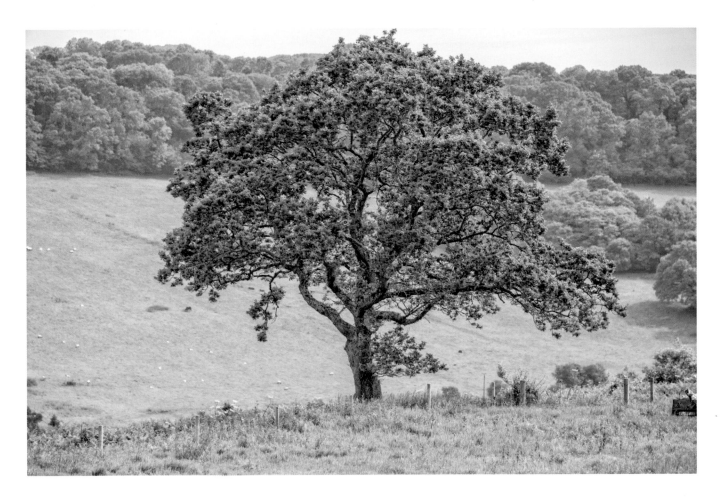

THE REFERENCE

Rather like people, no two trees are the same. Generally, however, they all have a trunk from which the main branches grow, and smaller branches and twigs on which the leaves grow. Different species have distinctive overall shapes and most of us can tell a pine from an oak tree at a glance. So shape is one of the key elements we need to be aware of when sketching trees. I have chosen a photograph of an oak tree as our focus in this project. Spend a little time studying the tree and imagine you are sitting on the grass in the adjacent field and you are going to draw it.

This project is an exercise to prepare you for when you do find yourself faced with a real tree to draw. You are going to make two drawings of the same tree so that you can experiment with two

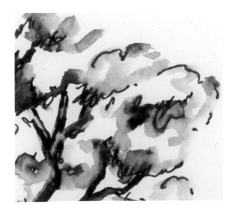

types of pen, a ballpoint and a felt pen. Both make fluid, free-flowing marks and are easy to use, especially when you are outdoors in a field.

In general, we are very sophisticated viewers and given just a little bit of information about something our eyes and brain will make up the rest. This is how you need to approach drawing the foliage. There is no need for you to draw every leaf; you would be bored and so would your viewers! Rather you are going to suggest the foliage and the viewer will do the rest.

Tip
Allow the eye of the viewer to complete the foliage.

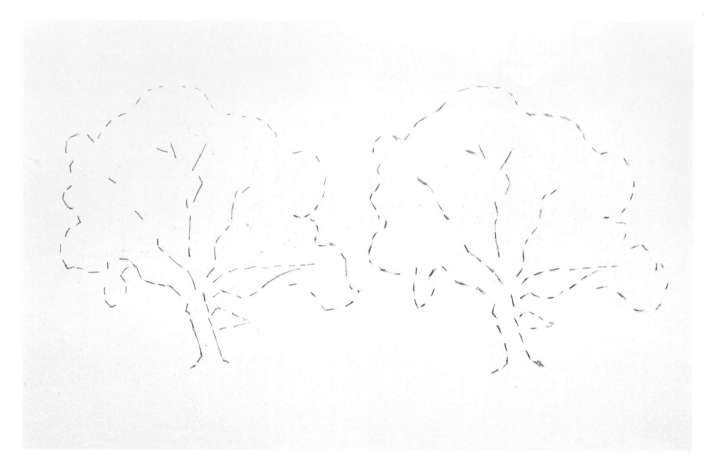

STAGE 1 : *Making a guide for your drawing*

To prepare for your pen drawings you are going to start by mapping out the overall shape and main trunk and branches of the tree using a pencil and small marks, rather like a dotted outline. These pencil marks will disappear once you get going with the pens and are only a guide to keep you on track.

Once you have drawn the first tree, trace over your marks using a piece of tracing paper. Then turn your tracing paper over, scribble over your marks on the reverse side, turn it back again and put it in place for your second tree. Draw over your original marks on the front, remove the tracing paper and… hey presto! …a second tree guide will have transferred onto your paper. You can reuse the tracing paper on another sheet of paper for more experiments later. You may need to scribble on the back again before using the guide for a second time.

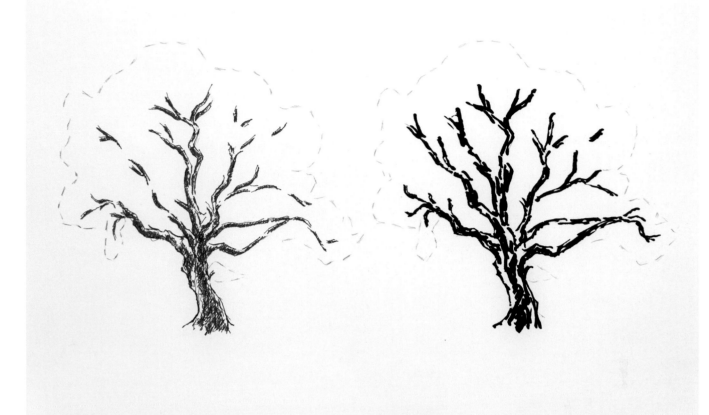

STAGE 2 : *The trunk and branches*

Look closely at the photograph and notice that the main trunk and branches are much darker and more solid than any other part of the tree. As you look higher up the tree, notice how the branches disappear behind bunches of foliage and then reappear again. They also get thinner higher up the tree. See the patches of light on the wood and also dark shadows.

Start with your ballpoint pen and the left tree. Begin sketching the trunk and branches over your pencil guide marks. Build your tree using small marks, squiggles, hatching and scribbles. Try to keep light areas between your marks so that your drawing has life in it and allow your outlines to have breaks in them. Scribble more densely where you want to describe shadows. Don't try to draw in every small branch!

Now use your felt pen on the right-hand tree. Experiment with the thick brush end and the smaller pointed end. Later you will add water to this drawing, so leave some white spaces. This pen makes thicker marks than the ballpoint pen, so you will have to make fewer marks and yet still convey the same information.

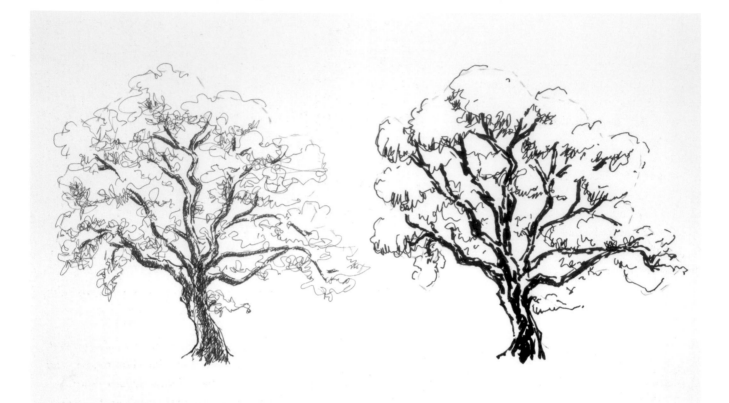

STAGE 3 : *The foliage*

Look again at the photograph of the tree. The foliage forms a series of masses; those forms overlap each other. Each mass is catching the light at the top and is a bit darker and in shadow underneath.

Using your ballpoint pen and making a fluid, light, scribbly line, indicate some of those masses on your drawing. Make your scribbles denser under them and use just a very light, broken curve for the tops. Try not to overdo it and keep lots of light in your drawing.

Take your felt pen and, again, keeping lots of light, draw in the masses of foliage on the right-hand tree. You need hardly draw the tops of the masses because when you add water later you can pull the ink round to describe the top.

STAGE 4 : *Finishing touches*

Gently and carefully erase any pencil guide marks that may be showing on your drawings. At the base of both trunks add in some grass to ground your trees.

Take a brush and water and lightly activate the ink on the right-hand tree. Touch the trunk and branches and grass with the water. With your brush, pull the ink from each foliage mass from the shadow to the light at the top. This creates a middle tone, which gives form to the masses.

Next time you are out in a field with your sketchbook and a pen, feel confident that by keeping things simple you can capture the essence and distinctiveness of a tree without any difficulty.

OTHER IDEAS

Trees are a great favourite of mine and appear in most of my sketchbooks. They have such a variety of shapes and forms and constantly change in the breeze and the light, so they provide endless interest to draw. Sketching outside in front of a tree is best – we gather so much more information than we realise as we look. I made the coloured sketch below in Greece then later, when I was home, I made a very large oil painting from it. I hadn't photographed the tree, so all I had for information was this little drawing and my memory.

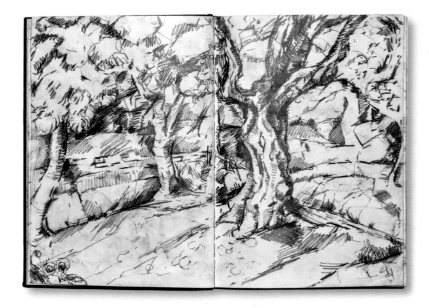

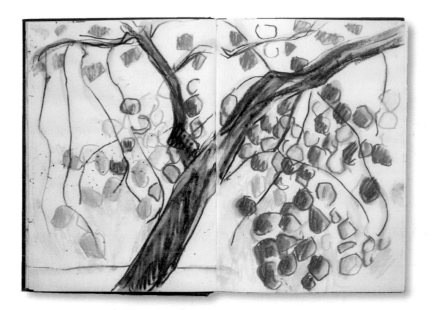

Try getting up close to the trunk of a tree and making a detailed drawing of the patterns and ridges on the bark. These can form abstract patterns and be used as inspiration for more paintings later.

I like using a range of media in my drawings and I encourage you to do the same. Also gather the leaves and seeds from the trees and make studies of those, too.

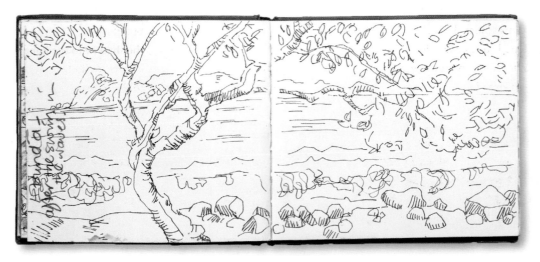

FOCUS ON
Finding Inspiration

As an emerging artist, what do you notice that catches your eye? What winks at you and says 'draw me'? Look at the world around you and begin to see it through the eyes of an artist. Make a list of what you notice and gather ideas for drawings. Take photographs and collect images from magazines. Collect interesting objects, artefacts and fragments. Bring these things into your workspace. Surround yourself with inspiration that is personal and particular to you. Then draw! Develop a passion for drawing that has meaning and feeling and which is yours.

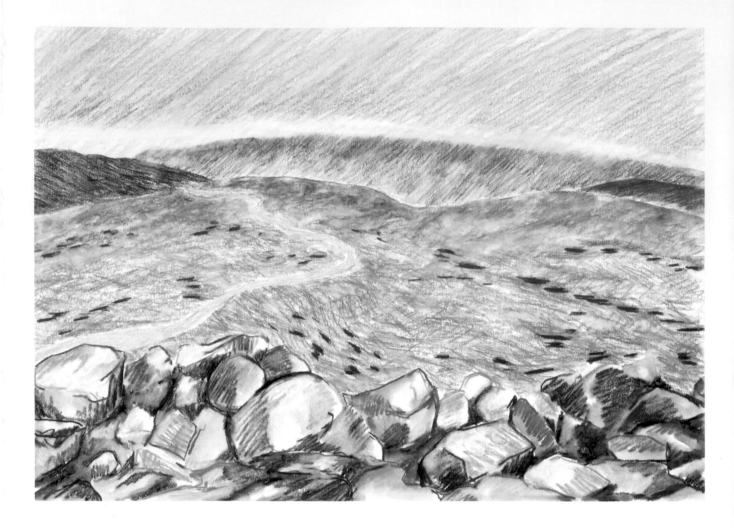

Scottish Landscape

*This project is about capturing the essence of a wonderful landscape view,
perhaps inspired by a holiday photograph. You will learn something of perspective
and work in colour for the sheer pleasure of capturing the scene in all its glory.*

YOU WILL NEED

*a reference photograph of a hilly landscape • A3 sheet of cartridge paper
HB graphite pencil • eraser • set of water-soluble, coloured wax pastels
medium-sized soft brush and water*

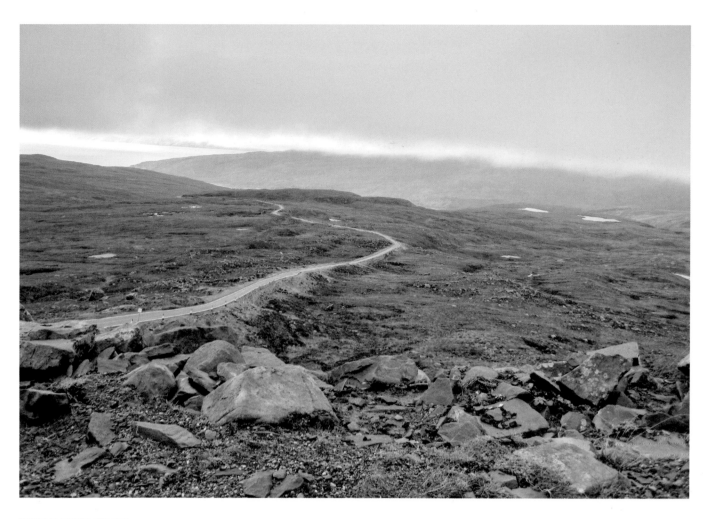

THE REFERENCE

You may live in Scotland and have this stunning landscape on your doorstep or perhaps you go there on holiday. Or maybe you've visited Cornwall, the Lake District, Switzerland or Crete and have taken photographs of the magnificent scenic landscapes found there, too. In this project you will use one of those photographs to make a drawing of the landscape and, in doing so, encompass distant atmospheric perspective, overlapping hills, the middle ground and the sharp detail of the foreground.

When faced with an awe-inspiring vista and the urge to capture it in a drawing, the task can seem over-whelming. Everything is so vast! But if you look at the view again

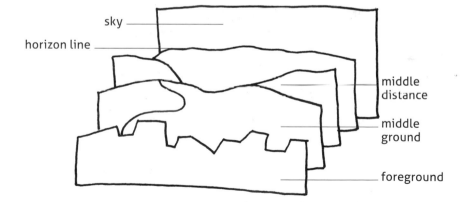

and think of it as a series of layers from the top of your page to the bottom then the job becomes more manageable.

At the top there is the sky, then lower down is the horizon line of a distant hill that looks a bit misty where the air is higher and thinner. This is called atmospheric perspective and can make distant hills look blue or purple.

Next there are a couple of hills we can see at each side; these form the middle distant ground. The next layer down is the big middle ground of the moor and the road going through it. The last layer, the foreground, is right at your feet and comprised of those angular, rugged rocks, which are an opportunity to add sharp, focused detail into your drawing.

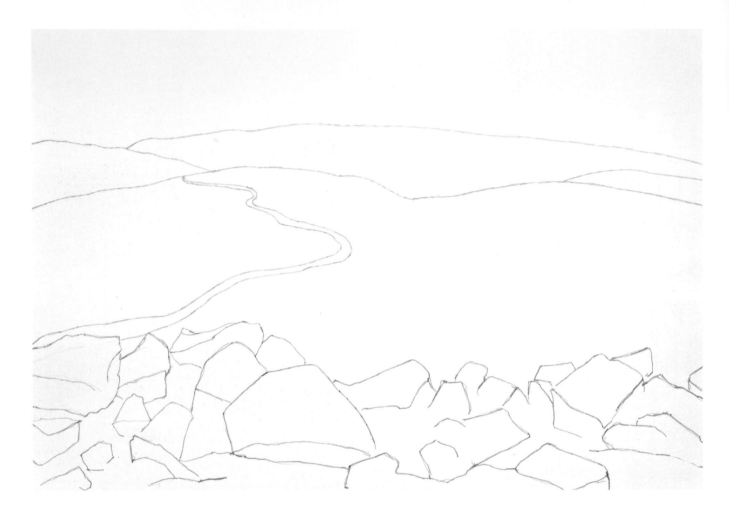

Tip

When faced with a huge vista it can be helpful to use a window frame like the one you used in the Tulips project (see page 30). Hold the window frame up and look through it to select a limited area of the landscape to be your subject. Draw only what you can see through the frame.

STAGE 1 : *Composing and mapping out your drawing*

Take your pencil and map in those layers right across your paper. Estimate where each layer comes by looking at the edges of the photograph and the edges of your paper. The sky takes up about a third, distant and middle ground a bit more than a third, and the foreground just less than a third. Keep your drawing simple but informative.

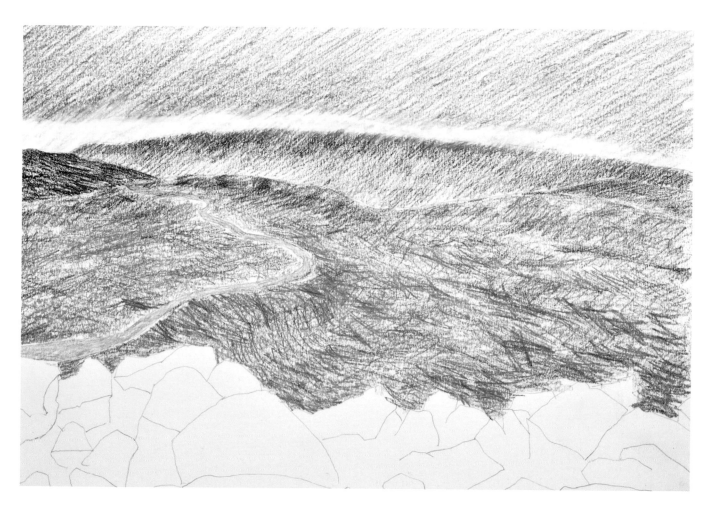

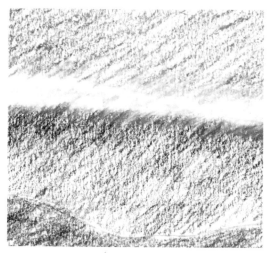

I erased some blue pastel to create the cloud, then used white to create the misty effect. Keep the same diagonal hatching for the next layer, which is the distant hill.

STAGE 2 : *From sky to the middle ground*

Next, begin drawing with your water-soluble, coloured pastels. Start at the top and work down through each horizontal layer of your composition.

For the sky, I used light blue, periwinkle blue and white pastels, and diagonal hatching across the whole sky, blending the periwinkle blue along the misty cloud line. For the distant hill, I used grey then violet and Prussian blue. Blend your colours lightly, allowing the white paper to remain visible in places.

Next, we move on to the side hills. Change the direction of your marks, following the direction of the land. Blend lilac and Prussian blue for the left hill and periwinkle blue and Prussian blue for the right hill. Now tackle the large area of the middle ground. First use grey and white to mark in the road. Then cover the whole middle area with orange – work lightly, first horizontally then vertically. Use purple to give a little shading to the tops of the gentle hillocks. Then use russet to work over the whole moorland, feeling the direction of the rough ground. Make marks that are shorter and more visible to give the feeling of coarse vegetation. Then use yellow ochre to work over areas that are brighter, blending and hatching the colours over each other.

STAGE 3 : *The foreground*

So far you have worked sedately down through the layers of this landscape, sensitively blending your colours to create a sense of distance and wide open space. Now you have reached the colourful craggy rocks and it is time to liven things up a bit! Grab orange, yellow, magenta, red and pink for the rocks, and Prussian blue and purple for the shadows. Use bold marks, and change their direction as you feel your way over the surfaces of those rocks. Make them strong. Surprise yourself and have fun!

Remember, your drawing is an interpretation of the photograph, not a replica.

STAGE 4 : *Adding water*

Now you must tread carefully. You are going to return to the top of your drawing and gradually and carefully work your way down through the layers using a brush and water to enrich the coloured pastels. Use a spare piece of paper to rest your hand on as you are working. Use your brush as you did your pastels, following the direction of your marks. Work lightly so as not to destroy your drawn marks and don't overload your brush with water.

You have created an artist's impression of a stunning landscape.

OTHER IDEAS

I always take my sketchbook with me
when I travel and I find water-soluble
pencils or wax pastels are a very
manageable way of bringing colour to
my sketches – they travel well and are
easy to use. Often I will put the colour
on the page *in situ* and add the water
when I'm back home. These mountain
sketches were made in Italy and France.
Of course, I also take photographs and
I'm sure if you look back through your
old holiday photographs you will find
some that you can work from to make
further drawings. If not, then books and
magazines have full colour photographs
of all sorts of terrain. It's a good
idea to start a collection of reference
photographs of landscapes from around
the world for further work.

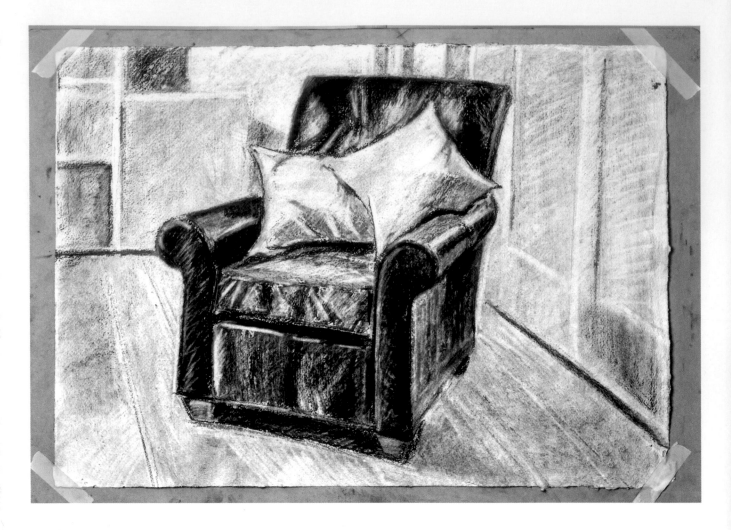

Comfy Armchair

Do you have a big, comfy armchair that you like to sit in? Something solid and heavy?
In this project you are going to make a big drawing of your armchair on an A2 piece
of paper using rich, black, velvety charcoal. We will take a fearless approach to perspective
by simply mapping out your chair in relationship to the space and objects around it.

YOU WILL NEED

an armchair • A2 sheet of semi-rough cartridge paper

drawing board and an easel, if you have one • masking tape

2B graphite pencil • eraser • thin and thick charcoal

small soft rag or piece of chamois leather

paper stump • can of fixative spray

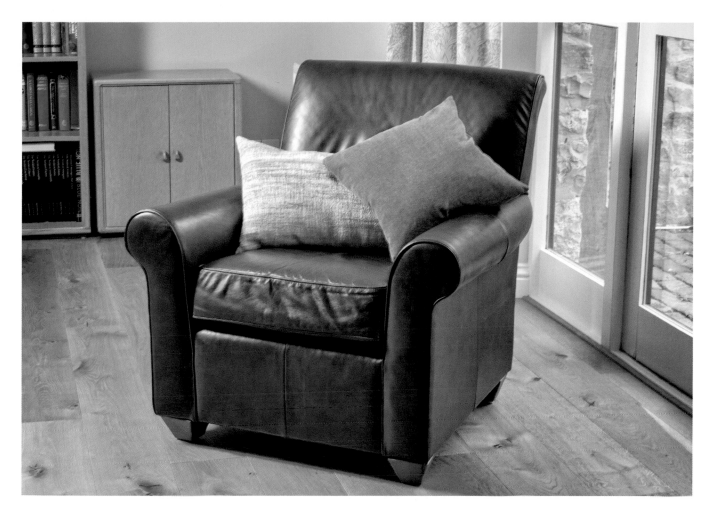

THE SET-UP

Choose the chair you are going to draw. Set yourself up so that you are viewing it at a similar angle to the one in the photograph above. Tape your paper to the drawing board and either sit with it propped on your knees or place it on an easel and stand up to draw. Your viewpoint will change if you are standing or sitting, so make this decision before you start and always return to the same viewpoint and height throughout your drawing process.

Observe the immediate environment around your chair. The places where walls, curtains, floors and windows meet the edges of your armchair can help you draw its shape accurately, acting as markers when you are mapping out your drawing (*see diagram right*).

When faced with an angular object to draw I regularly hear new artists say, 'But I don't know how to DO perspective'. My response is, 'Yes you do!' As a human being living in the physical world you know about physical things. You can see and feel if something is an incorrect shape or the wrong scale. You know if a chair is too wonky for you to sit on or if a doorframe is too small for you to pass through. You judge things with your eyes and body. You are deeply knowledgeable.

To use that knowledge in a drawing you simply have to look and keep asking yourself questions about what you are seeing. By comparing each part of your chair with what is around it you are collecting information to transfer into marks on your paper.

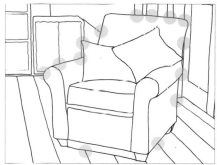

Tip
Look at where other aspects of the room meet your chair.

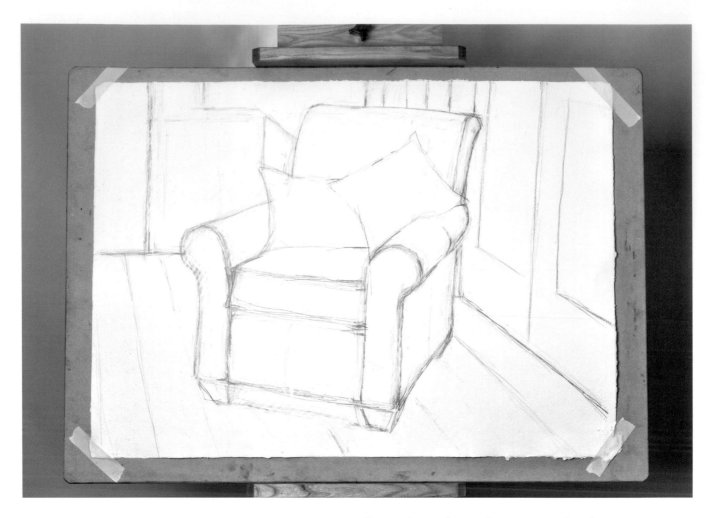

STAGE 1 : *Composing and mapping out your drawing*

Imagine vertical and horizontal lines through your chair (hold up the edge of a piece of card, a ruler or your pencil and close one eye if it helps). Use these lines to assess if parts of your chair or cushion or room are parallel with them or not. If not, do they slant down or up and by how much? Estimate and make a mark. Do the same again and again across your drawing, mapping out your chair. Keep looking, reassessing and restating your marks.

Do the same thing again to estimate if one part of the chair is longer or shorter or the same length as another part. Transfer that information to your drawing. Keep making mapping marks and changes until it feels right. Trust your eyes.

Use a pencil, and an eraser if needed, and spend as much time as it takes to map in your chair and adjacent parts of the room onto your paper. Draw them simply and clearly but also keep your drawing soft and fluid.

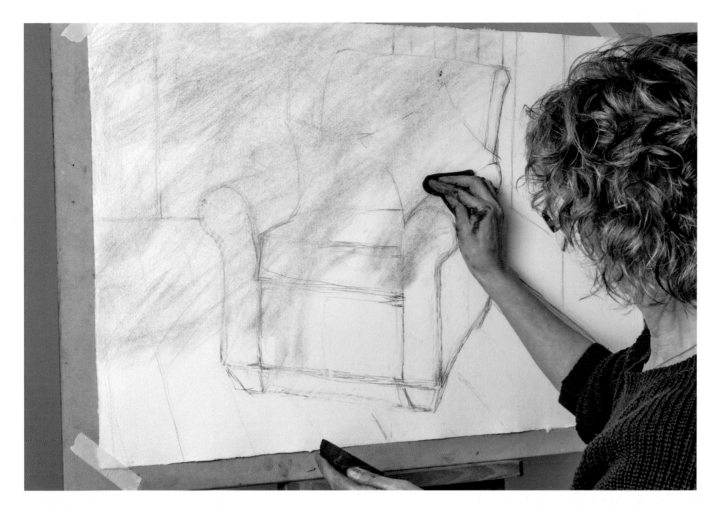

Tip

I keep my piece of chamois leather in a tin with my loose pieces of charcoal. That way it gathers charcoal dust and is always ready and loaded up to be used to wipe large areas of tone onto my work.

STAGE 2 : *Background tones*

Although this project is about the armchair, the chair is not in isolation and needs to be set in its room environment. So first, you need to do some work on the background. To create a middle tone all over the background, first rub your small rag or piece of chamois leather with charcoal and wipe the dust over your paper. Work all over the paper, including the chair. You should still be able to see the mapped-in drawing you did in stage 1. Then, take your eraser and 'draw' with it. Draw in the light areas such as the wall behind the chair, the window frames to the right of the drawing and parts of the floorboards on the floor. Then add in some deeper middle tones using charcoal.

STAGE 3 : *The armchair and cushions*

The armchair itself is tonally the darkest area
of the whole drawing but if you look at each of
its sections you can see very dark areas, middle-
dark areas, medium tones and white highlights.
Use your charcoal to work each area of the
chair, and build the tone across the plane of each
surface. Don't worry about the white highlights
for now. The cushions are tonally much lighter
than the chair but have subtle tones across their
surfaces to show their roundedness. Shade these,
too. Use your fingers or a paper stump to help
blend the charcoal tones. Don't be too rigid with
your marks, allow air into your work and feel the
chair. I would rather sense feeling and see the
drawn mark than see 100% accuracy. You are
making an interpretation of what you are looking
at, not a plan for a builder or a furniture maker.

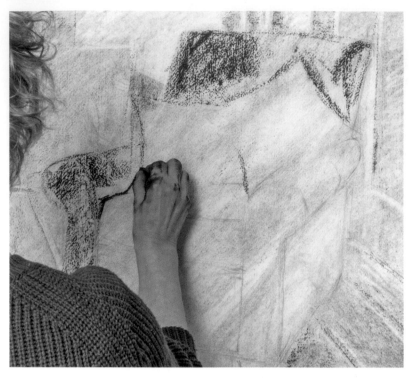

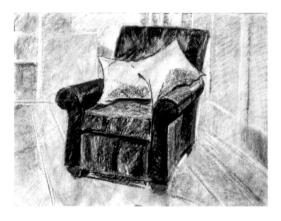

STAGE 4 : *White highlights and final details*

Now stand back and look at your drawing
overall. Is one area catching your attention?
That often means it needs more work. Look for
edges that need to be sharpened and for places
that need to be darker, such as the shadows
around the seat cushion and under the chair.
Look to the background – is there a need for
any deeper tones? Then take your eraser and
draw with it to create the highlights on the chair.
You might need to keep cleaning the eraser on
a scrap of paper to keep it working efficiently.
The cushions may need some extra light, too.
Finally, spray your finished drawing with
colourless fixative to help prevent it rubbing off.

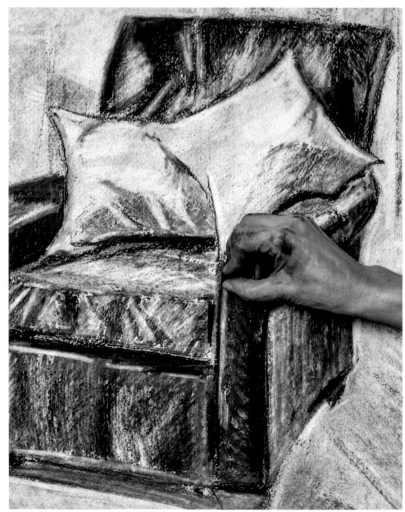

OTHER IDEAS

It is amazing how much personality
a piece of furniture can have. Chairs,
tables, chests or cupboards, whether
antique or ultra modern, make
interesting subject matter for drawing.
Our homes and the homes of our
families and friends are bursting
with drawing opportunities. I made
these drawings at my friends' houses
and the chairs reflect something of the
character of their owners.

Another idea is to open drawers and
doors and make drawings of the
contents. Stacked china, hanging
garments, curios, and bits and bobs
are ready-made still lives. Sometimes
the more haphazard the contents of
a drawer, the more interesting the
drawing will be, so resist the temptation
to tidy it up.

You could also take your sketchbook to
a museum and search out some unusual
chairs and pieces of furniture to draw
from other times and other places.

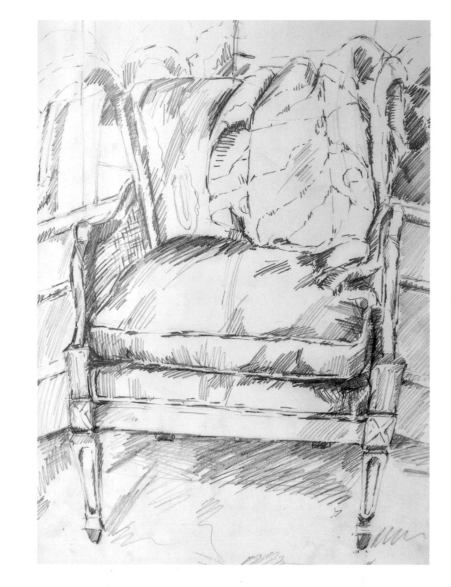

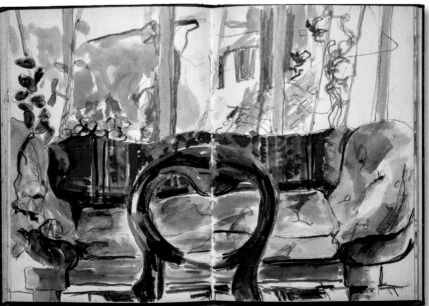

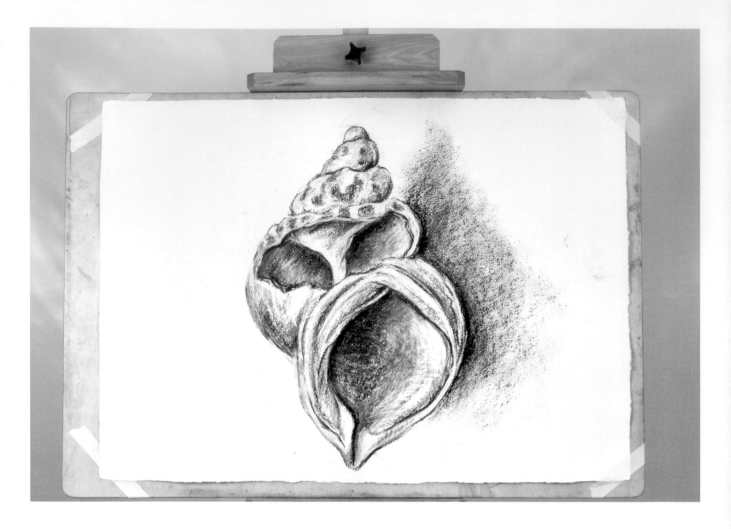

Sea Shell

Walking along the seashore you might pick up a shell that has been dashed against the rocks.
The broken shell reveals fascinating and beautiful deep inner cavities and curves.
In this project you will make a large, expressive drawing of a shell using charcoal.

YOU WILL NEED

a shell • A5 scrap card • putty tack • A2 sheet of rough-surfaced cartridge paper
drawing board and easel, if you have one • masking tape
thick and thin charcoal sticks • white compressed charcoal or white chalk
eraser • paper stump • can of fixative spray

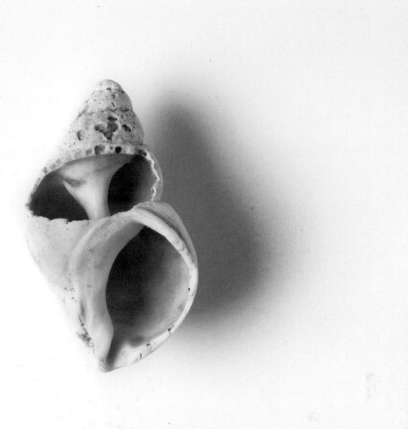

THE REFERENCE

It's a good idea to attach your shell to a piece of card with putty tack. This makes it look rather like a museum specimen but also means you can see inside the shell, which is not so easy to do if it is lying on a table.

Spend some time studying your shell. Check its proportions and how it is divided up. Look at its width and height and how the cavities are connected and each section is built upon the next. See the relationships between each part of the shell and how it has grown inside and out. Also study its surface pattern and texture.

Tape your A2 piece of rough cartridge paper to your drawing board, preferably on an easel if you have one.

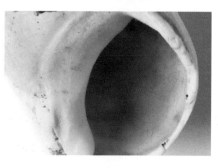

Look closely at the texture of the outside of the shell (top) and the smoothness of the inside (bottom).

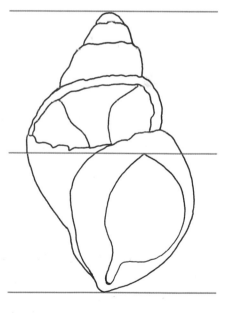

Tip

It can be helpful to imagine a horizontal line dividing your shell in half. Map in the shapes either side of the line.

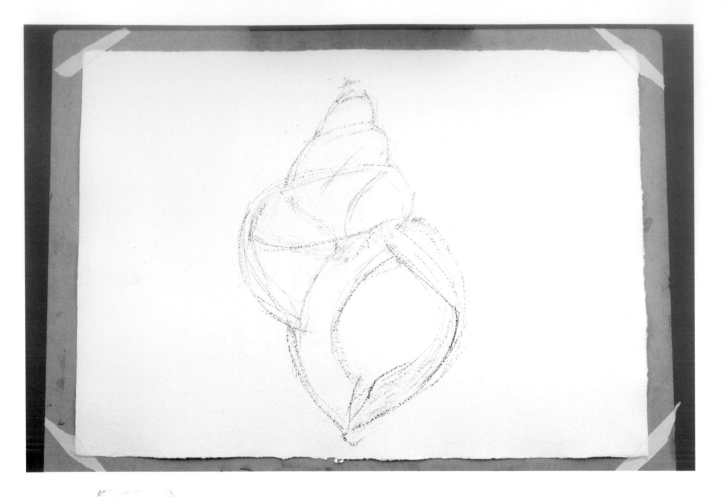

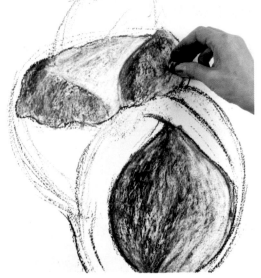

STAGE 1 : *Finding the shape*

Using a stick of thin charcoal, begin your drawing slightly to the left of the middle of your paper. Later the shadow will balance this slightly off-centre placement.

This shell is a wonderfully sculptural object and it's important to 'feel' your way around the curves and twists of its shape as if you were carving it. Allow for errors and simply restate your line if you aren't happy with it. Do this as many times as is necessary to achieve a flowing curve. There is no need to measure: you just need to look, estimate, make a mark and look again. This project is about looking at and feeling the curves of your shell and the curves you are drawing.

When you have a sketchy but satisfactory drawing, you can begin to add some tone to the inner chambers of the shell using thicker charcoal (*see left*).

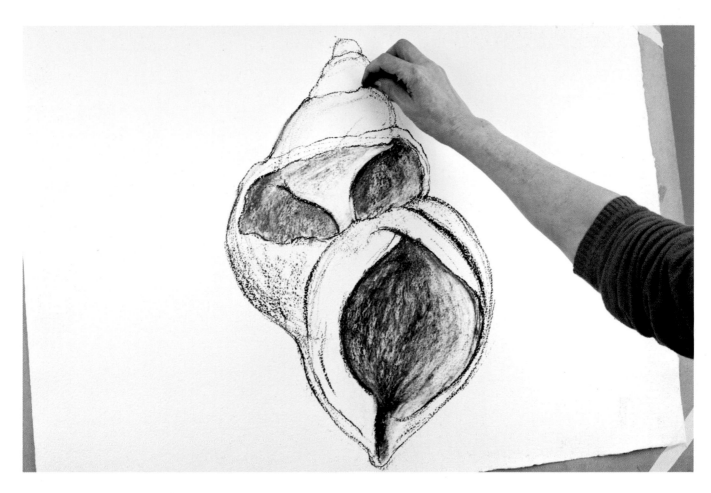

STAGE 2 : *Precision, tone and detail*

Now that you have the basic drawing in place, it's time to look more closely and be more precise. Draw your lines more accurately to describe the undulations caused by the broken shape and also the long, smooth lines around the opening. Build the tones inside the shell and on the outer curves. Use your thicker charcoal for the darker tones, and curve your shading to form the concave shape of the interior.

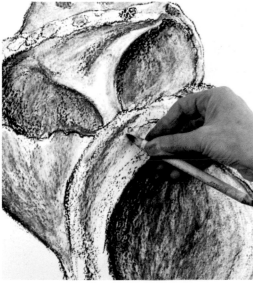

Tip

Use a paper stump to smooth out the curved, shaded tonal areas inside and outside the shell. Look at the outer parts of the shell and draw in some of the details of the textural surfaces.

STAGE 3 : *Adding white*

Using either a stick of white compressed charcoal or white chalk, work over the surface of your drawing to enhance places where there are highlights. Also smooth white over the lighter tonal areas. The white will blend with the black charcoal to give a more solid feel to the shell.

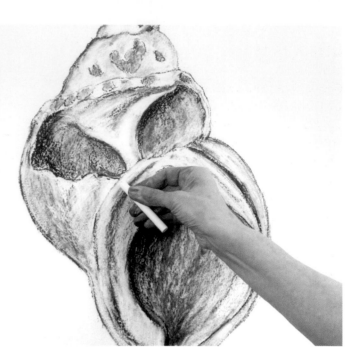

STAGE 4 : *The shadow and final adjustments*

Use your thicker piece of charcoal to shade in the shadow to the right of the shell. Look at its shape and how it echoes the silhouette of the shell. Then smooth it with the flat of your hand, blending and softening it around the edges. Now check all over the drawing and make final adjustments. Do not be afraid to amend shapes and tones and add in details. Erase your marks here and there if they are too solid. Spray with fixative and your monumental shell is now complete.

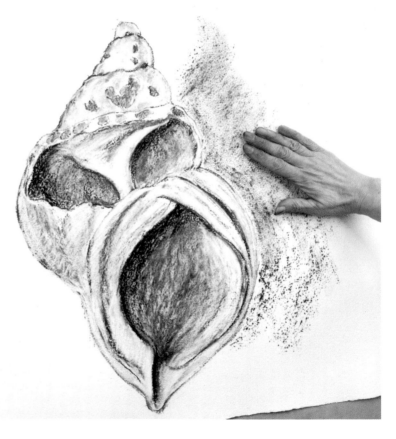

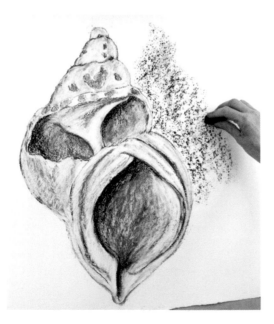

OTHER IDEAS

Combing the seashore for interesting
shells and stones is a favourite pastime
and I love returning home with a piece
of driftwood and a pocketful of shells,
all ready for the next still life. It is
the intricacy of their shapes, patterns
and textures that interest me and the
challenge of trying to draw them.

I also regularly visit my local
aquarium to see living creatures and
take my sketchbook. Aquariums usually
have a variety of shellfish and exotic
fish, which are curious to observe up
close and fascinating to sketch. It can
be quite tricky to make a drawing of
a swimming fish. The fluid lines of the
dogfish in my lower study help to give
a sense of the moving creature.

Sometimes, though, I will make a
drawing of a fish before I eat it. This
mackerel (*top*) was waiting to go in the
pan but I couldn't resist sketching its
beautiful shape and markings.

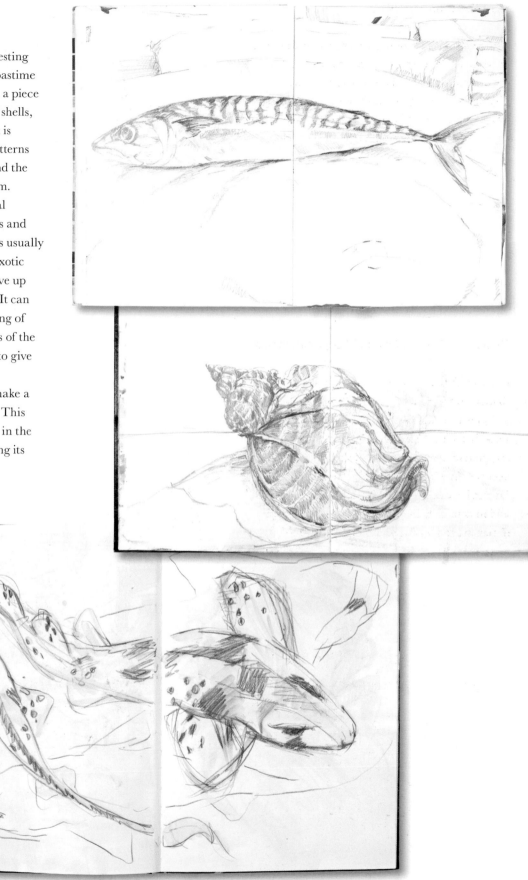

FOCUS ON
A Drawing a Day

No matter what you want to achieve in life, whether it is playing golf, learning the piano, ballroom dancing, yoga or drawing, the only way you will improve is by practising. I recommend that you set yourself the challenge of making a drawing a day. Of course you can do more than one a day but one is the absolute minimum. You need to flex the muscles of your brain, your eyes and your fingers. It doesn't matter what you draw – it could be your toothbrush – but the discipline, like cleaning your teeth, is to do it daily. One easy way is to make yourself a grid of rectangles and simply draw in one each day. Rather like a patchwork quilt, it will grow because you put the time in. If you only have a minute to spare then make a one-minute drawing; if you have an hour then spend an hour. Do not destroy your drawing – even if you don't particularly like it, the objective is to simply do it, to practise.

Tip
If you don't
know what
to draw, look
at these
examples
for ideas.

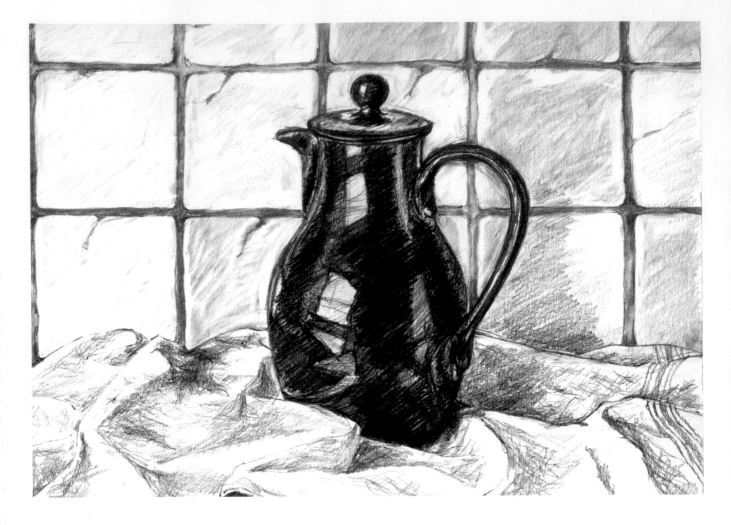

Kitchen Jug

In this still-life project you are encouraged to carefully observe the shape of a jug against a tiled background. The grid formed by the tiles can assist in mapping out your drawing. This is a tonal drawing, using soft graphite pencils to shade the roundness of the jug, its reflections and the undulating cloth on which it stands, as well as providing an opportunity for fine detail work in the background.

YOU WILL NEED

a still-life set up, similar to the photograph • A4 sheet of cartridge paper B and 3B graphite pencils • ruler • eraser

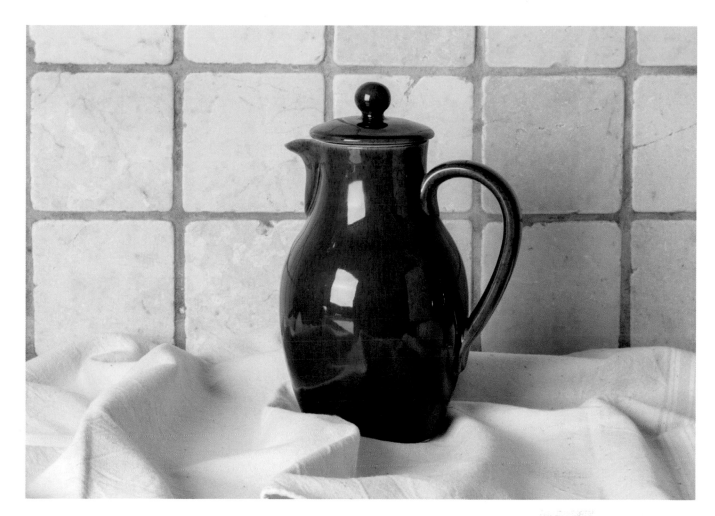

THE SET-UP

Look at the key areas (*see right*) around the jug shape. Notice how the positive form of the jug overlaps the squares of the tiles behind and the tile shapes become the negative spaces. The positive and the negative shapes interlock like a jigsaw puzzle. It can help to draw the negative shapes and, in so doing, create the correct positive shape of the various parts of the jug. Practise small sections before you begin your main drawing to get an idea of how this works.

 Patterns, stripes and checks in still-life arrangements can be extremely useful as guides when mapping out positive forms.

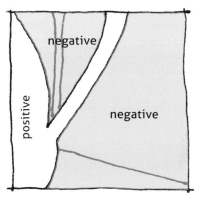

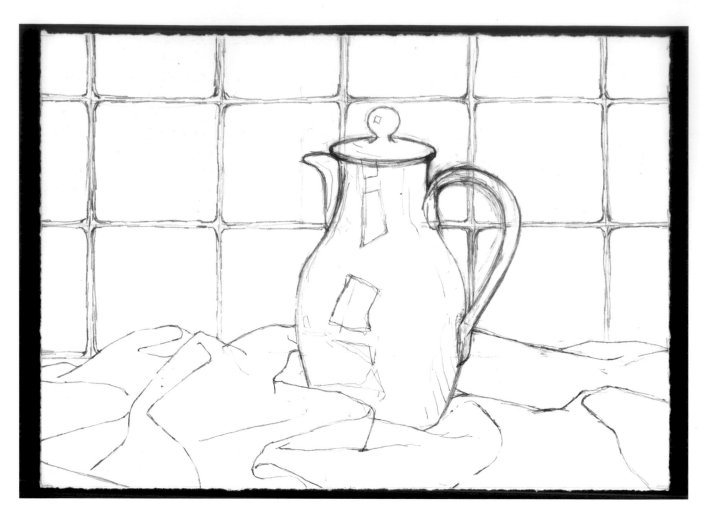

STAGE 1 : *Mapping out your drawing*

It is worth spending a generous amount of time with this first stage of your drawing, as the accuracy you achieve will underpin the rest of the piece. You are going to map in the tiles, jug and cloth of the set-up as a line drawing using a B pencil. You will map in the tiles first. In the photograph the centre line of grouting falls almost in the centre of the paper. Decide on the size of your tiles and lightly draw a grid using a ruler as a guide. The grid marks the centre of the grouting. Now look at the shapes of the actual tiles, which here are rustic in style. Draw them freely, leaving a gap for the grouting.

Now look at the shape of the jug overlapping the tiles. Refer back to your earlier practice of positive and negative shapes. Using the negative space shapes made by the tiles around the jug, observe and map in how the jug and tile shapes interlock. Keep looking, estimating, making marks, erasing, restating your line until you have mapped in the shape of the jug. Look at the ellipse of the lid and ensure it has rounded 'ends' not points.

Now you can draw the cloth outline. Look at the undulations and folds. Check where they sit by looking upwards to the tile shapes and use them as a guide to estimate their position and the shapes they form. Draw the folds.

STAGE 2 : *The tiles*

You are going to work on the tiled background now. First, shade in all the visible grouting between the tiles using a medium pencil tone. Look closely at the tiles. There are subtle changes of tone in each tile and also cracks and blemishes, characteristics that make each tile unique. Gently shade each tile. Sharpen your pencil and draw in the cracks and irregularities on each.

Tip
Use the eraser to 'draw' into your pencil marks to create texture and light.

STAGE 3 : *The jug*

The jug is the shining centrepiece of this drawing, rich and dark with reflections and highlights that help to describe its volume and shape. The tones of the jug range from white through to a deep, dark black. Observe the transitions between each tone carefully and vary the pressure of your pencil to achieve a full range from light to middle and darker tones. Use your 3B pencil and build the tones, varying the angle of your shading marks as you draw so that you feel your way over the rounded surface of the jug. The very light tonal shapes can be sharpened up with an eraser if necessary. Keep the outside edges and curves of the jug sharp; it is made of a hard, ceramic material so your marks need to emphasise this. Note the lighter tones down both sides of the jug created by reflections.

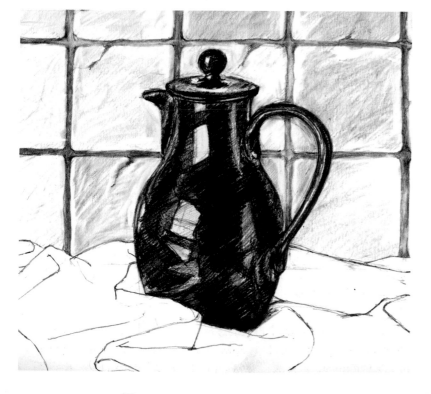

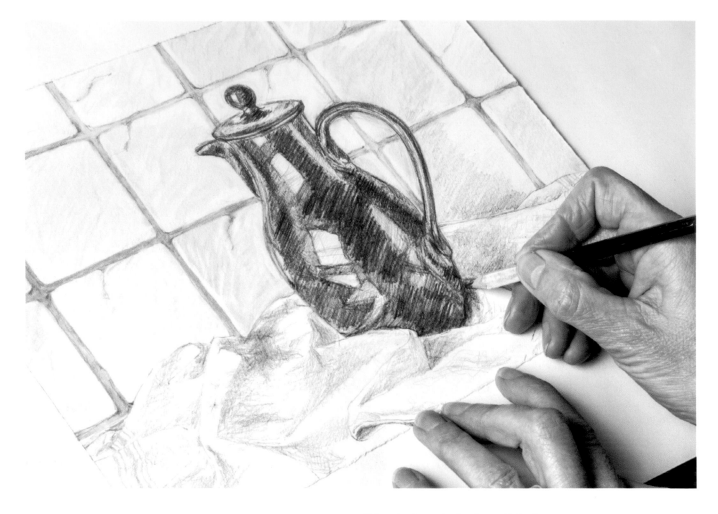

STAGE 4 : *The cloth and shadow of the jug*

Tonally, the cloth is similar to the tiled area of the drawing but the material is different. Soft shadows and undulations require to be treated with gentle shading and soft marks. Your drawing will be more interesting if you find different sorts of marks to describe different materials rather than using the same mark throughout, which can look generic and boring. Define light, sharp edges by the darker shadows behind them.

There is a shadow cast by the jug onto the cloth and the tiled wall. Note how dark this is at the base of the jug and how it is less harsh on the wall. Shade this softly on the tiled area and the cloth.

Your still-life drawing is now complete.

OTHER IDEAS

A sketchbook and a pencil or two are all you need to put in a little drawing practice. You don't even need to move from your armchair to find something to draw, as no matter where you are there will be a still-life set-up. A toy discarded on the floor, a pile of washing, a handbag, toiletries, ornaments on the mantelpiece, the larder and its hoard of bottles and jars, the clutter on the dressing table… all are available and exciting subject matter. Look for different textures, such as lace, glass, fur, metal, and patterns of flowers, stripes, checks and weaves.

Try out different pencils from a hard and finely sharpened H to a big soft 8B and find out what you can do with them. Experiment with a variety of marks, and challenge yourself to find ways to describe a furry surface or a glass bottle covered in reflections. Use light and shade. Make drawings to record your surroundings. In years to come, they could bring back many memoirs.

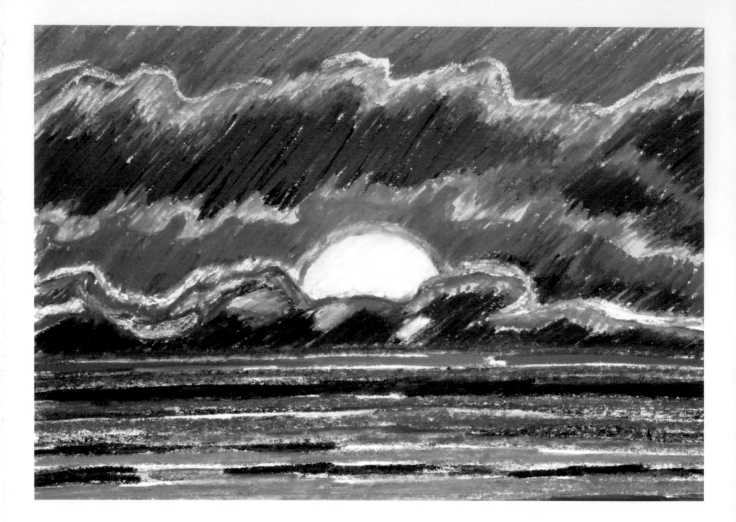

Sunrise

This is a joyous project that I believe you will find yourself repeating again and again just for the sheer pleasure of it. This drawing is of a sunrise but it can also be completed as a sunset. You can choose to work it using water-soluble coloured pencils, water-soluble wax pastels or water-soluble ink blocks. I suggest you try out all three and see which you prefer. In this example I have used the water-soluble ink blocks. When it is finished it looks like an embroidered fragment of an exquisite tapestry.

YOU WILL NEED

a reference photograph of a sunrise or sunset (or the real thing!)
A4 sheet of cartridge paper • A4 piece of scrap paper • HB pencil
water-soluble ink blocks • brush and water • craft knife (optional) • ruler

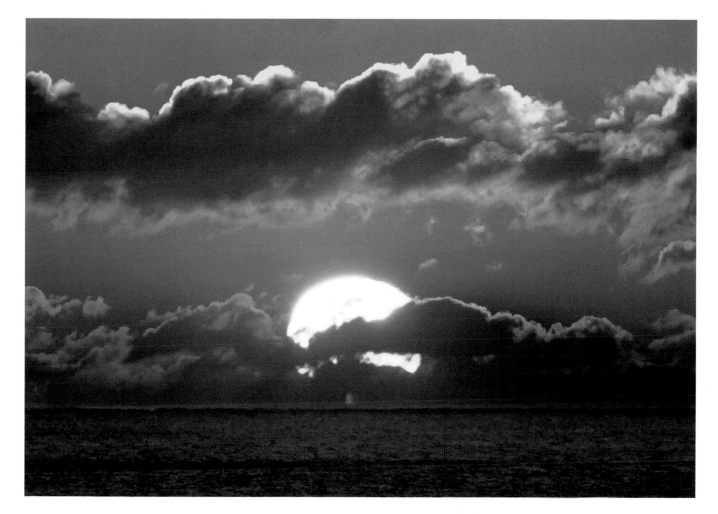

PREPARATION

Prepare your paper by folding the scrap piece of A4 paper in half. Lay this in the centre of your A4 sheet of cartridge paper and draw round it. Remove the guide and make your drawing inside the rectangle. When it is finished you can cut it out along the pencil lines using a craft knife, or leave it as it is if you prefer.

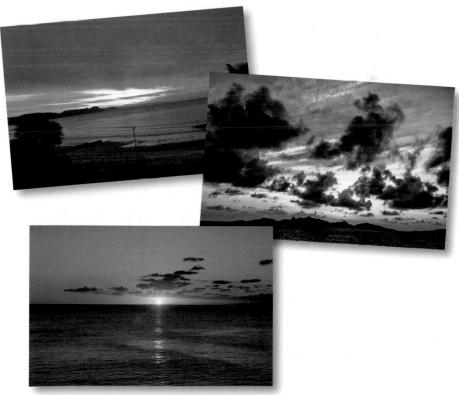

Tip
It is a good idea to start making a reference collection of photographs of the rising and setting sun so that you have a selection of images to work from for future drawings.

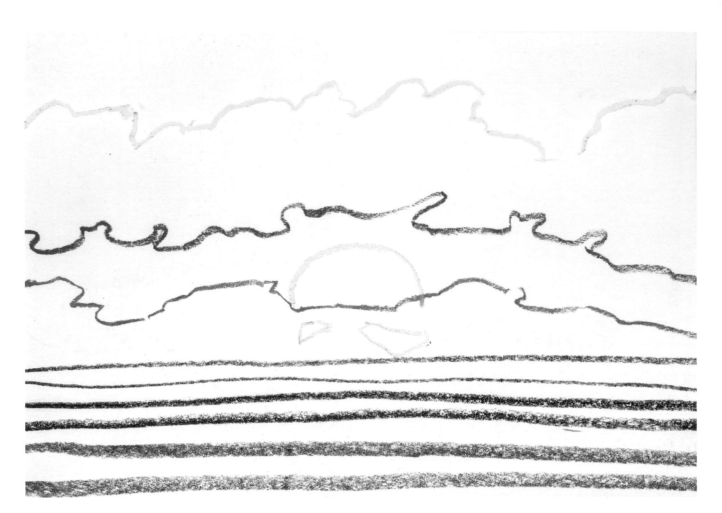

STAGE 1 : *Composing your drawing*

The nice thing about this project is the freedom it gives you to be creative with colour and marks, but first you need to compose your drawing. Look at the photograph and, using a purple ink block, make a line across the lower quarter of your rectangle to mark where the horizon is. Add more horizontal lines to mark the sea. Then mark the position of the sun using a yellow ink block. The clouds and the sky above and between the clouds are arranged in bands. Select colours that match each different area and mark them across your paper. Simplify the cloud shapes into coloured layers. This stage is about planning your space.

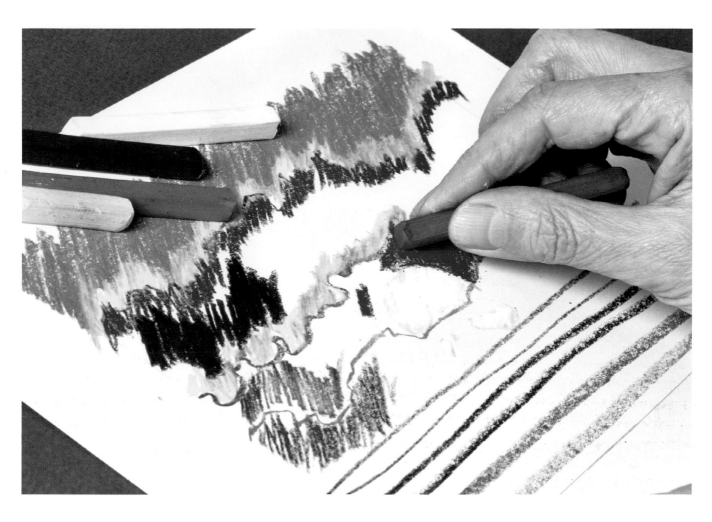

STAGE 2 : *The sky*

Sunrises and sunsets can be quite bizarre. Heightened colours mix and blend into each other and they often appear unreal. The light changes quickly so you have to work fast if you are drawing it in real time. Using a photograph for reference of course means you can work more slowly, but I feel it is important not to be too precise – you want to retain that sense of catching a moment in time before it all changes. Therefore I recommend using free-flowing marks like scribbles, hatching and squiggles. Water-soluble ink blocks are an ideal medium for this as they glide smoothly across the paper. Later, you can intensify the colours with water.

Work from the top of your paper down to the horizon. Choose colours that match the layered bands of clouds and sky. Allow the colours to overlap and blend but also leave little bits of white paper between your marks to allow air into your drawing. Be adventurous and free with your marks.

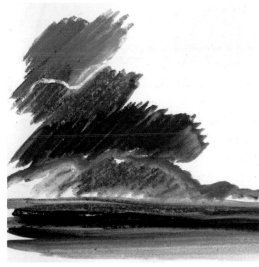

Tip
Practise blending colours and using different marks.

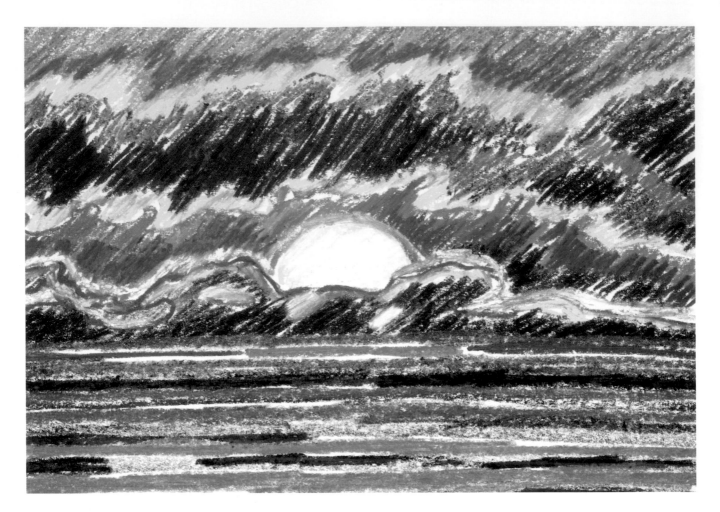

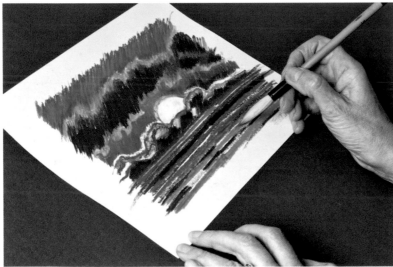

Tip
Try not to lose all your creative drawing marks with too much water, as your marks add originality to your drawing.

STAGE 3 : *The sea*

The sea in this piece is tonally much darker than the sky but it is still rich in colour. Use purples and blues in horizontal marks with a bit of orange and pink near the horizon. Working with horizontal marks emphasises that 'this is sea'; it is a different element to the air above. Again, leave flecks of white paper showing to energise the water.

STAGE 4 : *Adding water*

You are going to add water to your drawing with a brush in a similar way to the Tulips project (see page 30). Start with the lightest colours first. Don't forget to wash your brush between colours otherwise some will turn muddy. Do, however, blend other colours together if it is your intention to allow them to mix.

OTHER IDEAS

Living by the sea and being an early
riser means I see many sunrises.
However, I still say, 'Wow!' when I open
the curtains to a fuchsia-pink sky and
a purple sea. The wintertime is always
the most dramatic. My sketchbooks
are full of rapid, sprawling drawings
of intensely coloured seas and skies.

Even if you can only see a patch of
sky, an interesting task to set yourself
is to do a drawing a day of the bit you
can see. Clouds in all their different
forms are a great challenge to draw.
Keeping a record for a week or even a
month is a good way to develop a daily
drawing discipline.

People often ask me how they can loosen
up their drawing skills. Drawing quickly
is one way, and when you are trying to
capture the ever-changing sky you are
forced to make rapid marks. There is
no time for procrastination when you're
trying to catch a fleeting cloud!

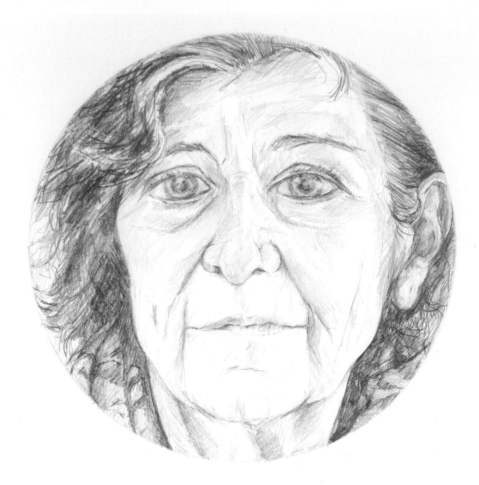

Self-Portrait

Making a self-portrait is always the best way to start portraiture because,
of course, you are always present when you want to draw! In this project you will
draw yourself by looking in the mirror. I have used a round mirror but any convenient
mirror will do. You will study how your eyes, nose, mouth and ears relate to each other
and use pencil tones to shade and describe your features.

YOU WILL NEED

yourself • A3 sheet of smooth cartridge paper
compass or 7⅞in (20cm) diameter plate • B and 3B graphite pencils
mirror • eraser • paper stump • pencil sharpener or craft knife

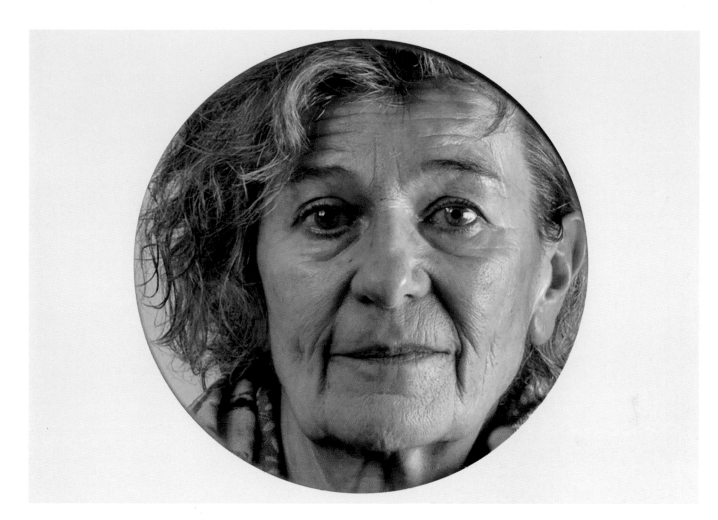

THE REFERENCE

Look in your mirror. As a baby, the first image we work out in our mind is that of two eyes, a nose and a mouth. As human beings we understand faces; we recognise people by the arrangement of their features. Most people have eyes, nose, mouth and ears in more or less the same place, but there are, of course, subtle differences between all humans. Drawing a portrait is about looking very closely at those features then getting them in correct proportion to each other, specific to the sitter.

Look at the red horizontal lines in this diagram (*see right*). Observe how they pass through the eyes to the top of the ear, and the tip of the nose to the top of the ear lobe, and the mouth to just under the ear lobe. Looking across the features in this way can help you to draw them accurately.

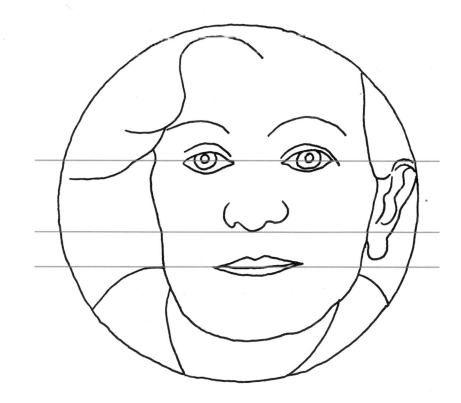

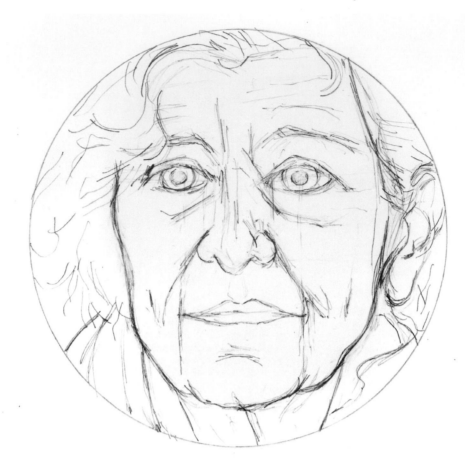

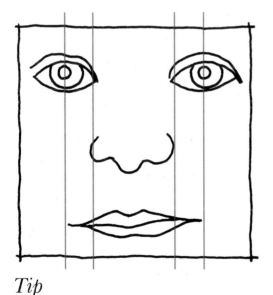

Tip
Imagine vertical lines and mark in the curve
of the nose and the width of the mouth.
Shape the lips.

STAGE 1 : *Mapping out your portrait*

For my drawing I have taken an A3 piece of cartridge paper on which
I have drawn a $7^{7}/_{8}$in (20cm) circle. I will draw inside the circle.

Making a realistic representational drawing of anything requires you to
look at one point of your subject, make a mark on your paper, look how
that marker relates to another point on your subject, estimate and make
another mark, then to repeat this again and again. Revisit your marks
and restate them, erase and make tiny adjustments. This is how you map
in your drawing of your face. Start with the shape and size of your face.
Then look to the horizontal line of the eyes and mark them in. Look at the
curve of the eyelid and how much of the iris is showing in the eye socket.
Work horizontally and vertically over your drawing, constantly comparing
the distance between marks, estimating which part of one feature lines
up with another. Use a B pencil and small marks to build an accurate line
drawing in this way.

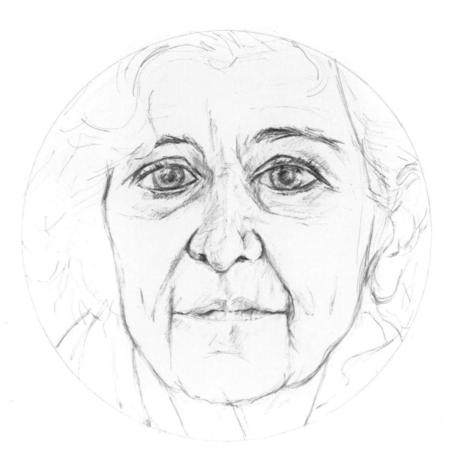

STAGE 2 : *Eyes, nose and mouth details*

When you are happy that you have all your features accurately in place, you can begin to develop your drawing to look three-dimensional with tonal shading and precise line work. Use both your B and 3B pencils. Start with the eyes. Look closely at the folds of skin and how the eyeball sits within them. Observe the white highlights in the eye, below the eyebrows and around the eye. Begin shading, as you have in earlier projects, to build up the tones, working gently and sensitively. Imagine your pencil is actually moving over each curve, crease and mound. Feel your way as if you were touching the face with your pencil. Sharpen your B pencil and work on the folds of skin and eyelashes. Work from the eyes to the nose and down to the mouth. Compare tones and ask yourself, 'Is this lighter, is this darker, how does this compare with that?' Build your features as a sculptor would with clay, bit by bit, adjusting as you go.

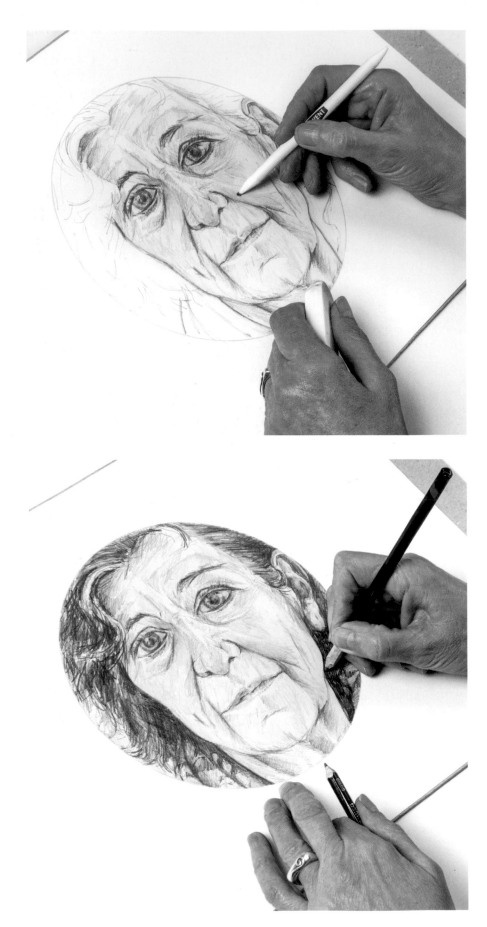

STAGE 3 : *Facial skin and ear details*

Now continue over the rest of the skin and round to the ear. In my drawing the face is lit from one side, so there are shadows and highlights all round, helping to describe the forehead, cheekbones, jaw, chin and neck. You can use a paper stump to smooth out the skin and an eraser to draw in the white highlights. Creases and wrinkles can be sensitively added with fine pencil lines. Deep shadows and highlights in and on the ear help mould the ear and describe the form. There are also deep shadows under the chin on the neck. Use your 3B pencil for these.

STAGE 4 : *Hair and scarf details*

Note how the hair grows out of the skin above the ear and at the top of the forehead. Use your sharpened B pencil to draw in the hair following the direction of growth. You will need to use some darker tones on the hair with your 3B pencil and then use the sharpened B pencil where you want to describe individual strands. Shade in the lighter middle tone of the background behind the hair. Work the darker hair over the top. Next look at the scarf and how it curves around the neck. The dark tones of it also help to define the shape of the jaw and neck. Indicate the pattern on it for interest.

If you have used a round mirror you could draw in a frame as in the original photograph if preferred, or keep the drawing as a simple circle as I have.

OTHER IDEAS

If you carry a sketchbook with you, especially when travelling by train, you will always have something to while away the hours of your journey. Fellow passengers often snooze or read so sit still, and you can grab the opportunity to get some portraiture practice in undetected. Often I use a water-soluble, ultra fine rollerball or ballpoint pen to make quick, fluid marks. Friends and family who are sitting still watching the television also make good subjects. Most rather like the idea that you find them interesting enough to study!

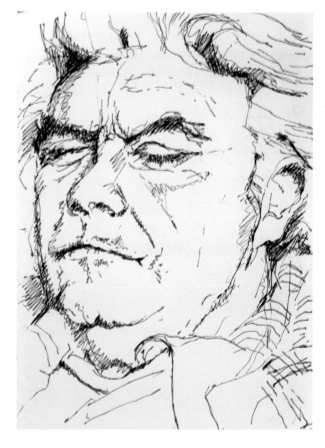

FOCUS ON
Learning by Looking

No matter what town or city in the world I find myself in I will always make time to visit a museum or art gallery. In the museums, I love to look at the various antiquities and study how they were made and decorated. In art galleries, I love examining ancient and modern paintings and sculptures. It isn't always about liking what I am looking at, but it is about studying how the artist or sculptor or craftsman made their mark. I learn from their marks. Sometimes I make drawings from the pieces I am looking at and this is something I highly recommend. It needn't take very long – it can be a 30-second scrawl in my sketchbook – but my marks will remind me of theirs. If I can, I buy a postcard on my way out to add to my collection or stick in my sketchbook.

My other love is visiting the zoo. Although I know the creatures I am looking at would be happier in the wild, I also know they are protected in a zoo. It is a privilege to stand before a beautiful animal, amphibian or bird and draw them for real.

Make your own visits, make your own drawings, and collect knowledge and reference material through observation.

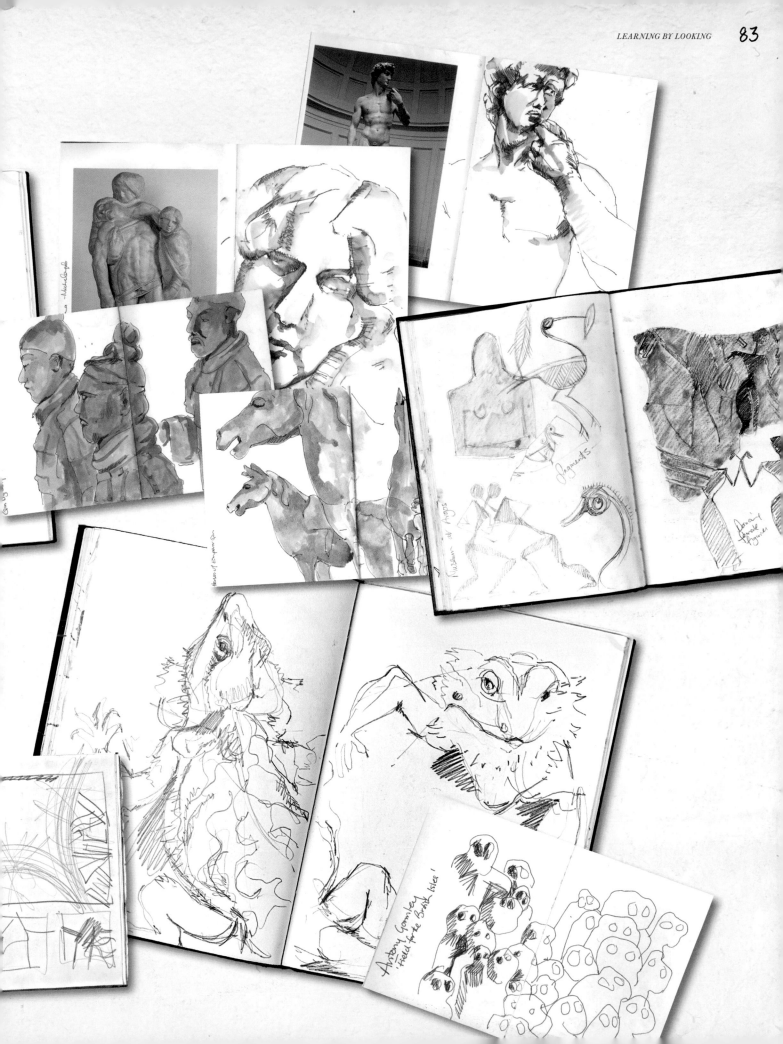

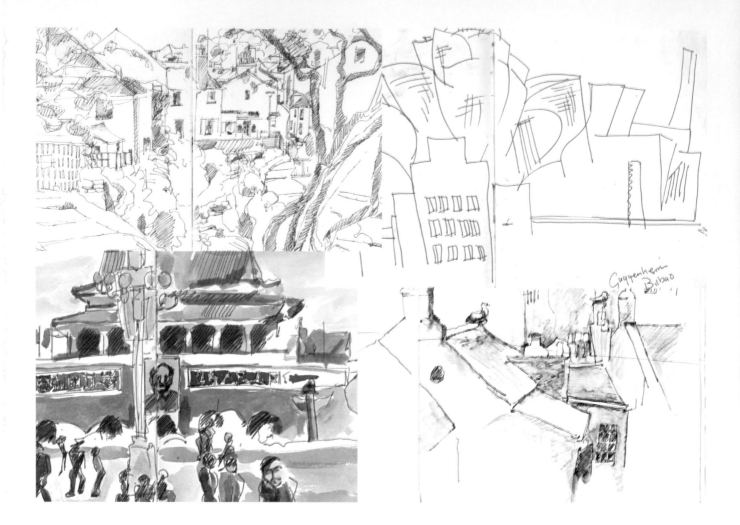

Out and About

In this project you are encouraged to take your sketchbook with you wherever you go and simply start drawing. Practise the elements of drawing you have explored in all the previous projects: observation, line, tone, colour, composition and mark-making. Draw freely and, most importantly, enjoy the experience.

YOU WILL NEED

hardback sketchbook • fine pen

Tip

Carry the minimum so that you can draw unencumbered.
Take colouring media if you wish, but remember a touch of colour
can always be added later, either from memory or from a photo taken
on your mobile phone. Keep it simple.

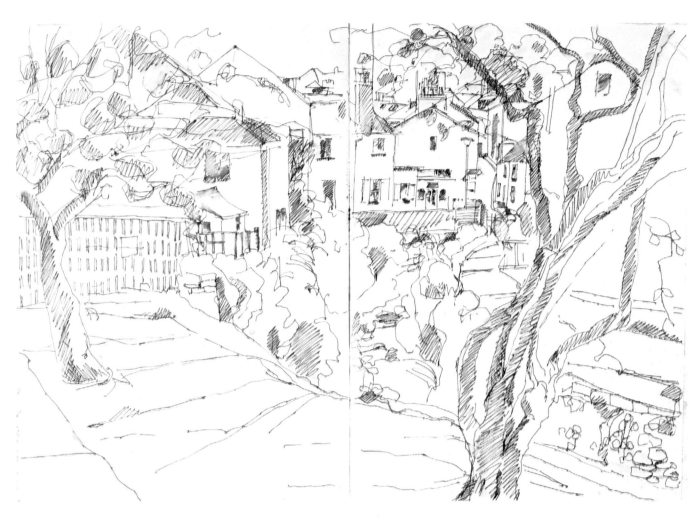

Tip
This is quite a concentrated drawing, so expect it to take you about an hour. Make sure you choose a spot where you can sit down to draw.

SKETCH 1 : *Trees and buildings*

This is quite a complex scene of trees, river, walkway and buildings. It could seem very complicated to sketch, but once you find your composition it becomes simpler. Begin by finding somewhere to sit and spend a few minutes just looking. Notice what could frame your picture. In this case, it is the two trees: they 'hold' the image together. I began by drawing the trees. What's between them creates a sense of distance, and the edge of the grass takes the eye through and back to the central pictorial scene. Simplify foliage and buildings – see them as shapes overlapping each other and intersecting. Allow the scene to build piece by piece, like putting pieces of a jigsaw in place. Keep the drawing simple and try not to get caught up in minute detail. Some detail, such as the fence behind the left-hand tree and the plants to the right of the other tree, add elements of pattern but both have been drawn simply. Use hatching to describe dark areas, such as roofs, windows and shadows. Keep picking out things that catch your eye but be selective and don't expect to draw absolutely everything. Find a location near to you with similar elements and try drawing a scene yourself.

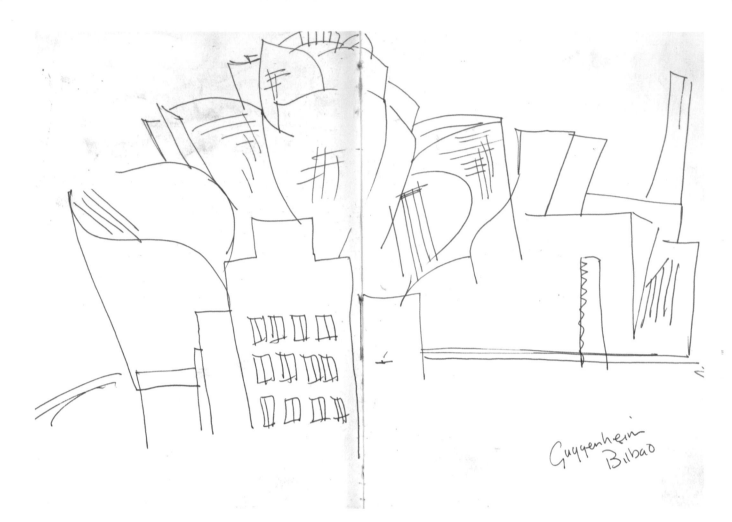

Guggenheim Bilbao

Tip

Show your drawings to a friend and get them to guess what the building is. If they are correct then you know you have captured the essence of it. If not, then go back and make more drawings until you do.

SKETCH 2 : *The Guggenheim Museum*

In contrast to the previous drawing, this drawing only took about two minutes! I emerged from the steps of the train station in Bilbao, Spain and was so excited by my first glimpse of the spectacular structure of the Guggenheim building that I just had to capture it immediately. I dropped my bag to the floor, got out my sketchbook and pen and made this drawing there on the spot. This is what I call a 'first response' drawing. I hardly looked at the page as I drew it because my eyes were on the building with only a glance at my marks. This type of drawing is not about intricate accuracy; it is about capturing the essence of the subject in rapid, fluid lines.

Go out with your sketchbook and pen and make a number of quick line drawings with the intent of capturing the character of your subject without worrying about all the details. Look at buildings with particular shapes, like churches, towers, skyscrapers and monuments, and select key lines that are specific to them. Draw them rapidly, spending only a minute or two on each drawing. Try not to judge your results too harshly and DON'T dispose of them. The more drawings you make like this the better you will get!

Tip
Add colour later at your leisure to give even more life to your sketch, as I did with this drawing. The touches of colour are very specific to the location – the flags of Tiananmen Square could only be red!

SKETCH 3 : *Tiananmen Square*

This is another quick-fire sketch but in this one I have tried to capture the details of the whole scene. I took a party of students to China and as we walked across this historic square, I realised that was probably the only moment in my life I would be in that place. Knowing I had only minutes, I just had to get it down on the paper as quickly as possible. What I want to impress upon you as an emerging artist is that it can be more important to do it than not to do it, even if the roof you draw is wonky, you put in six arches rather than nine and the people look odd. Take a photograph if you want a perfect architectural record but make a drawing if you want to capture how you feel.

So, go into a busy square, stand with your sketchbook and draw quickly. It could be a market square in a small town or an Italian piazza or London's South Bank. Take the opportunity to capture the place in a memorable, quick-fire sketch.

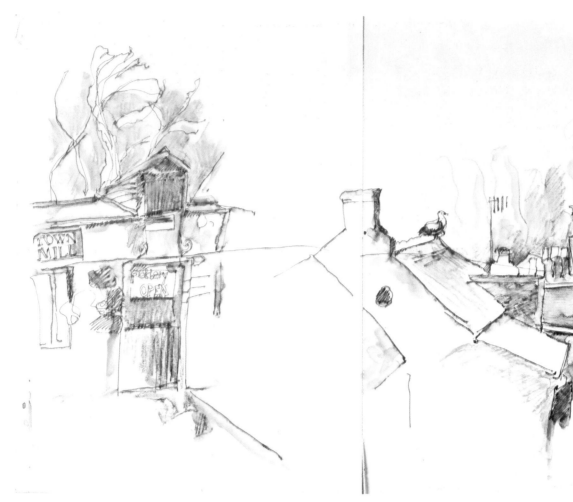

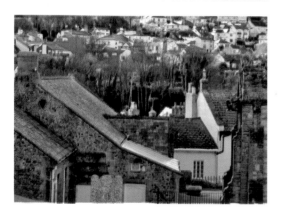

*The Town Mill
pottery and
the rooftops
of Lyme Regis in
south-west England.*

SKETCH 4 : *Two locations in one drawing*

In this, or I should perhaps say 'these', drawings I have used composition
to combine two locations in one town. By linking them on the double-page
spread they become vignettes depicting aspects of a particular place. There
is a connection between them physically on and off the page, with the
pointed rooftops helping us to make the pleasing visual link. I have been
very selective and economical with the amount of information I have put
in the drawings. For instance, with the rooftops I did not want to add in the
mass of townscape beyond the trees, so I allowed the trees to fade and by
doing so gave emphasis to the intersecting roof shapes. Touches of colour
were added later.

Take yourself out on a short walk and select two, three or four places to stop
and draw for a few minutes. Link your drawings over a double page of your
sketchbook. Draw only a detail of each place. Create a pictorial record of
the walk. This is a particularly satisfying thing to do when on holiday and
will evoke memories later.

OTHER IDEAS

For me, piano practice would be a bit of
a chore, which presumably is why I have
not progressed beyond the elementary
level. However, I definitely don't find
practising drawing using a sketchbook
a chore. It is a place where I can try out
all sorts of pictorial ideas without the
pressure of producing a 'finished' piece
and somewhere in which I can be free
and experimental. In these drawings
I am exploring composition, practising
building a picture, recording particular
places, being observant and selective,
and generally flexing the muscles that
I need to keep my skills fit. I hope to
inspire and encourage you to do the
same by keeping your own sketchbooks.

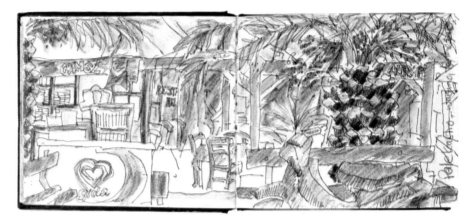

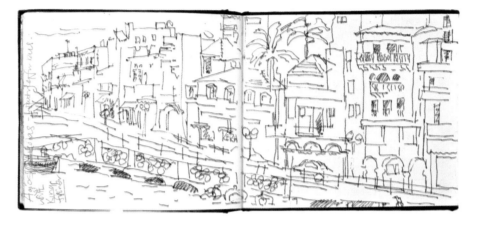

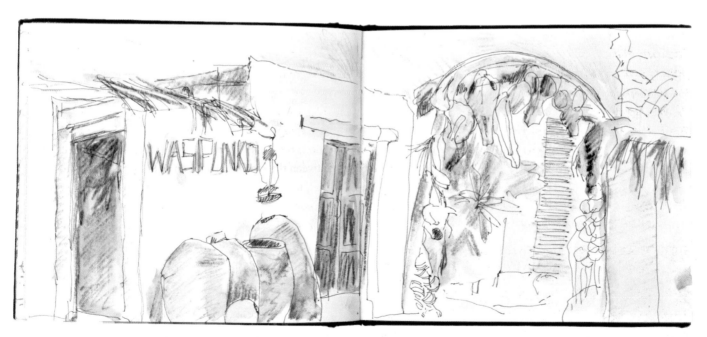

Conversions

International Paper Sizes			
A SIZES	*mm*	*inches*	*nearest US/Canada equivalent*
A2	420 x 594	$16^{1}/_{2}$ x $23^{3}/_{8}$in	C
A3	297 x 420	$11^{11}/_{16}$ x $16^{1}/_{2}$in	B (Ledger/Tabloid)
A4	210 x 297	$8^{5}/_{16}$ x $11^{11}/_{16}$in	A (Letter)
A5	148 x 210	$5^{13}/_{16}$ x $8^{5}/_{16}$in	Statement
Pencil Grades	**UK**	**US**	
	B	#1	
	HB	#2	
	F	#$2^{1}/_{2}$	
	H	#3	
	2H	#4	

Suppliers

I use and recommend these UK online art suppliers but I also support local art shops wherever I am.

UK

Cass Art
www.cassart.co.uk

Jackson's Art Supplies
www.jacksonsart.com

Seawhite of Brighton
www.seawhite.co.uk

US

Blick Art Materials
www.dickblick.com

Jerry's Artarama
www.jerrysartarama.com

Rex Art
www.rexart.com

Glossary

ATMOSPHERIC PERSPECTIVE
In art, atmospheric or aerial perspective refers to the technique of creating an illusion of depth by depicting distant objects as paler, less detailed, and usually bluer than near objects.

BLEND To merge marks together smoothly.

BUILD The creation of a line from a series of small marks rather than by using one continuous line. This can help when you are gradually working out the shape of an object.

CHARCOAL Charcoal is a drawing material consisting of wooden twigs burnt in the absence of oxygen, so as to become carbon. Artists generally use charcoal either as vine charcoal (created by burning sticks or vines) or powdered charcoal (used to "tone" or cover large sections of a drawing surface) or compressed charcoal (charcoal powder mixed with gum binder compressed into round or square sticks).

COMPOSITION The harmonious arrangement of the parts of a picture in relation to each other. It is how everything is arranged within the shape of paper you have chosen.

CONTRAST The use of light and dark tones or colours next to each other so that each will appear emphasised.

DECKLE EDGE Paper with a feathered or uneven or rough edge is described as having a deckle edge, in contrast to a cut edge.

FIXATIVE Thin, colourless varnish sprayed on drawings to protect them.

GRAPHITE PENCILS
These are the most common types of pencil, and are encased in wood. They are made of a mixture of clay and graphite and their darkness varies from light grey (hard) to black (soft).

HATCHING Groups of small parallel marks, which produce the effect of tone or density in a drawing.

HIGHLIGHT The lightest tone in a composition, occurring on the most brightly lit parts.

HORIZON The apparent line that divides the earth or sea and the sky. It is always at the eye level of the viewer.

MAPPING OUT Gradually planning the shape, design or composition of your subject on the paper. I also call this 'finding' your image sometimes. You are indeed making a map of sorts. It is the first stage of a drawing when you are feeling your way around the paper to find the right place for everything and making 'mapping' marks as you go.

MEDIUM The type of material used to make a drawing or other work of art. The plural of medium is media.

NEGATIVE SPACE The space around a physical object (can also be described as the background).

PAPER STUMP A useful little tool that looks like a pencil without the graphite and is made completely of compressed paper. It is used to blend and smudge charcoal, pastel or graphite on the paper, similar to using your finger to smudge but more precise.

PERSPECTIVE Techniques used to create the illusion of spacial depth in drawing and painting. Aerial perspective is the illusion of distance in landscapes or seascapes.

PIGMENT Natural or chemical coloured substance used in the making of coloured drawing media, such as paint, dyes, inks, etc.

POSITIVE SPACE The physical space an object occupies.

RESTATING The constant process of making a mark, looking, assessing and then 'restating' that mark if it isn't quite in the right place. Sometimes we erase the first mark and restate a new one in its place, other times we simply restate the second mark over the first. This process is continuous, rarely is the first mark the last mark.

SHADING Close pencil marks, which blend together to create lighter and darker tones, especially useful when trying to make an object look round, for instance.

TONE The degree of light to dark on the grey scale (from white to black) or of a colour.

About the Author

Christine Allison trained at St. Martin's School of Art, London, The New York Studio School of Drawing, Painting and Sculpture, and the University of Exeter. Her home and art studio overlook the sea in Lyme Regis, south-west England. Creativity is Christine's lifeblood and her career as an artist covers design, teaching, writing and painting.

She draws and paints with a passion and her immense works of birds of prey grace the walls of Middle Eastern royal palaces and prestigious offices. Back home in the UK her inspiration comes from the sea, the land and creatures of the natural world. Her work is colourful, expressive and full of energy, moving between realism and abstraction, and often large in scale.

Christine firmly believes drawing underpins all art forms and she has encouraged and inspired many through her teachings and workshops to feel the same. Creativity, passion, professionalism and joy are her objectives in life and in her art.

Acknowledgements

My grandmother Isabella Buchanan (1882–1976) first showed me drawings made by my great grandfather Cuthbert O'Conner Westgarth (1842–1937) when I was barely four years old. I can remember having to reach up to peer over the edge of the table at the small portfolio that held sheets of creamy paper covered with exquisite swirls and intricate patterns drawn in pencil. My creative soul was opened by those drawings and I have never forgotten them. I am in gratitude to Isabella and Cuthbert for little did they know that my career in art began by seeing those drawings.

I am grateful to GMC Publications for recognising my ability to inspire others to draw by commissioning me to write and illustrate this book. Thank you to my editor Dominique Page for her professional experience and enthusiastic response to the project.

Working with designer and photographer Terry Jeavons to create the look and layout of the book has been a pleasure. I am grateful for his meticulous attention to detail, and his skill, knowledge, experience and patience. It has been a harmonious working partnership and one of mutual respect for our individual talents.

I would also like to say thank you to my family for forgiving me for the times I have given art more attention than them! My gratitude for their love and support of me is beyond measure. Thank you to my sister Tyrrian, my children Sally, Jenny and Tom, my grandsons Oscar, Ruben and Bowen, and especially my husband Harry.

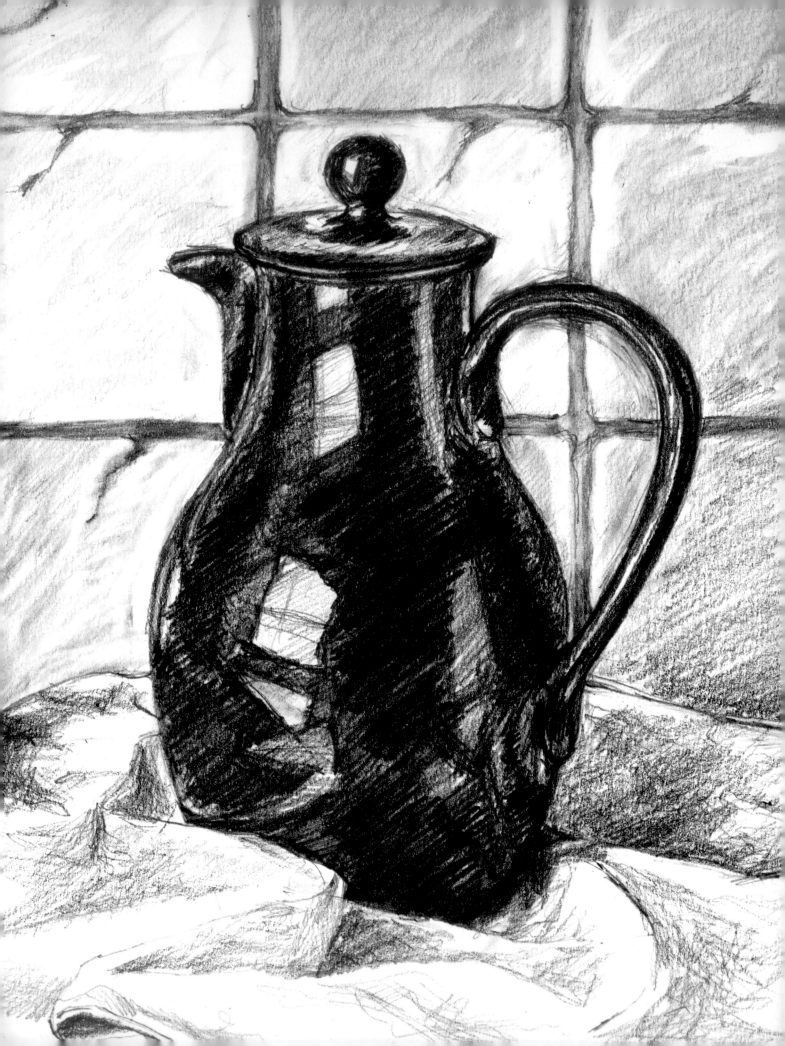

Index

To order a book, or to request a catalogue, contact:

GMC Publications Ltd
Castle Place, 166 High Street, Lewes, East Sussex
BN7 1XU, United Kingdom
Tel: +44 (0)1273 488005
www.gmcbooks.com